IMAGES
of America

TIPPECANOE TO TIPP CITY

THE FIRST 100 YEARS

To Gene,
You are living
history!

Susan
Furlong

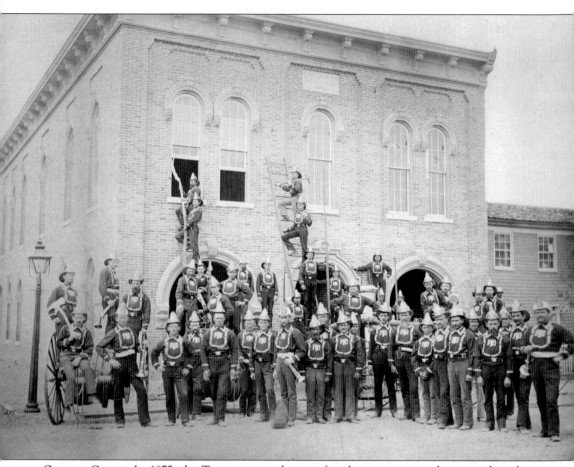

ON THE COVER: In 1875, the Tippecanoe volunteer fire department members posed in their brand-new uniforms with their new ladders, hoses, and nickel trumpets for signaling each other at fires. (Courtesy of the Tippecanoe Historical Society.)

IMAGES
of America

TIPPECANOE TO TIPP CITY

THE FIRST 100 YEARS

Susan Furlong

ARCADIA
PUBLISHING

Published by Arcadia Publishing
Charleston, South Carolina

Printed in the United States of America

Library of Congress Control Number: 2012942213

For all general information, please contact Arcadia Publishing:
Telephone 843-853-2070
Fax 843-853-0044
E-mail sales@arcadiapublishing.com
For customer service and orders:
Toll-Free 1-888-313-2665

Visit us on the Internet at www.arcadiapublishing.com

*To the first "Away Girl," Grace Kinney, who came from Texas to make
Tippecanoe her home and made preserving its history her calling.*

CONTENTS

ACKNOWLEDGMENTS

As an "Away Girl"—someone who was not born and raised in Tipp City—I want to thank the Tippecanoe Historical Society for giving me free access to the museum and all its files.

Writing two plays about Tippecanoe began with the encouragement and support of my friends Ruth Ann White and Peg Hadden. My thanks to the cast who starred in and the audiences who attended *Tippecanoe—Our Story* in 2004 and *Tippecanoe—Our Lives* in 2007.

Hats off to all the people of Tippecanoe who brought their histories to life in a way that can only be captured by seeing it light up in their faces.

Thanks to my editors, Matt Bayman, the former owner and editor of the *Independent Voice*, who let me write a historical column, "Olde Tippecanoe," and to Sandy Shalton of Arcadia Publishing for her encouragement.

Betty Eickhoff has been invaluable in sharing all she knows about life in Tippecanoe and good-naturedly correcting what I did not know.

My gratitude and love go to my family, Greg, Luke, and Melissa, my granddaughter Allison, and my friends, Claudia, Tom, and Marilee, who know everything about me and love me anyway. Thanks to this wonderful town. You could not get me out of here with a crowbar.

Thank you to Bob Miller for summing up the reason I love doing this. "We were so busy living our lives that we didn't know we were living history." History is the people who lived it.

Above all, thanks to Grace Kinney, the first "Away Girl." She arrived from Texas in Tippecanoe with her husband, Hartman Kinney, in the 1930s. To fill her days, she researched her adopted home. Her files are invaluable, and it is my pleasure to add to them.

This book contains only a fraction of the people, places, and things that were and still are part of Tippecanoe. I hope you enjoy a taste of the first 100 years of this wonderful community.

All photographs, unless otherwise specified, appear courtesy of the Tippecanoe Historical Society Museum.

INTRODUCTION

Robert Evans came with his family to southwest Ohio when he was 15, settling on land near the border between Miami and Montgomery Counties. He married Esther Jenkins at age 23, and they made a home for themselves and their children. When Robert's father, Joseph, died, Robert inherited 190 acres and $50. He then sold the property and purchased 140 acres from David and Sally Clark for $700. On that property, he built two log cabins and began clearing the heavily forested land with his sons. After Esther died, leaving him with 10 children, he married her cousin Mary Jenkins and had six more children with her. His only intention was to provide a good life for his large family, but little did he know how events would change all that. And so, the story of Tippecanoe begins.

By 1820, it was well known that a canal would be built through Ohio that connected Lake Erie to the Ohio River in Cincinnati. It was estimated that it would cost the state over $10,000 a mile, and naysayers called it "Brown's Folly" after Ethan Allen Brown, the governor who proposed it. However, the Miami and Erie Canal turned out to be one of the most important factors in opening up the settlement of western Ohio. It gave farmers and merchants a way to get goods to market at a cheaper and faster rate, thus bringing business and settlers to the territory.

The work of digging the canal was backbreaking, and the camps became centers for disease and violence. To get workers, the state had to raise its daily wage from 30¢ to $1 and include three jiggers of whiskey, but soon the state was left with only prisoners who worked in return for getting their sentences shortened. Even so, it turned out that $10,000 a mile was not enough to cover the cost, and the total expenditure after 17 years was more than $8 million. Still, many visionaries realized that there was money to be made from this new modern mode of transportation, and they did not hesitate to take advantage of it.

Brothers Uriah and James Johns knew the canal would be coming through Miami County, but to make their fortunes they had to first discover its top-secret route. They approached the surveyor in the woods and asked him questions about where he was headed. He was evasive. Next, they tried bribing him, but he turned them down flat. Then they got him drunk, and he spilled everything he knew. Within weeks, the brothers had purchased 50 acres, including one acre and 100 square perches from Robert Evans. They then willingly sold the land back to the state for a profit so the canal could be dug through it. They also built a gristmill right beside the future lock and used the water provided by the state through the canal to power it.

An equally enterprising man was John Clark, who owned land a few miles to the west of the future canal. When he heard about what the Johns brothers had done, he began negotiations with his brother-in-law Robert Evans to acquire land on which to build a town beside the canal.

Robert Evans and John Clark were married to sisters, but Evans had no interest in establishing a town. However, as a strictly religious man, he did want to protect his 16 children from the evil influences of the bawdy life associated with the canal. He agreed to trade properties with Clark and, with Clark's additional payment of $6,750, moved his family to Clark's former property on

what would become Evanston Road. At first glance, it may appear that he made a poor deal, but not so. He had originally purchased the acreage for just $700, and he walked away with a profit, in addition to the value of the land, of nearly $7,000 in 11 short years.

In 1839, John Clark plotted out his newly acquired land into a town to be called Tippecanoe. He chose the name in honor of his friend, Indian-fighter William Henry Harrison, who had won an Indian battle in Tippecanoe, Indiana. When Harrison ran for president, his campaign slogan was "Tippecanoe and Tyler, too." He and his vice-president, John Tyler, won the 1840 election, but Harrison died of pneumonia a short 32 days later.

The canal officially opened on July 4, 1839. Crowds lined the banks, bands played, orators spoke, and cannons boomed. Everyone waited in the sun for the hero of Tippecanoe, William Henry Harrison, to sail down the canal past the reviewing stands, but he never came. The next day, most of the revelers came back, but Harrison did not show up that day either. Hardly anyone was left to cheer when on July 6, Harrison arrived, not in a canal boat, but in a carriage on the road. It seemed that the water reservoirs of Indian Lake and Lake St. Mary's were not ready, and there was not enough water to fill the canal. It was three more weeks before the first boat came down the new waterway.

The availability of modern transportation continued to be the cornerstone of Tippecanoe's growth. First came the canal, but within a few years came the invention of the steam engine and the railroad that ran parallel to the canal just five blocks to the west. This was followed by electric traction cars running through town, which were soon replaced on the nearby highways with busses, trucks, and cars.

Today, Tipp City is thankful for all the forward-looking people who began with a vision of a town on the canal, and by taking advantage of every opportunity over the years, created a lasting legacy for all the people who would follow.

One

ON THE CANAL

It was part foresight and part plain luck that put Tippecanoe on the map, right beside Lock No. 15 on the Miami and Erie Canal. A smattering of settlers had already built homes in southwest Ohio, but it was the entrepreneurs who saw the great potential in establishing a town so close to this modern waterway. They knew that there was money to be made and lives to be built. Tippecanoe has had its boom times and bad times, but its location on the canal began it all.

Before Lock No. 15 on the Miami and Erie Canal was built, the little hamlet of Hyattsville began about one mile west. This road led into the town founded by Henry Hyatt on land he purchased from Robert Evans. Hyatt had wanted his town to be the lasting center of life and activity, but once the canal came through, Tippecanoe surpassed it and, eventually, absorbed Hyattsville into its boundaries.

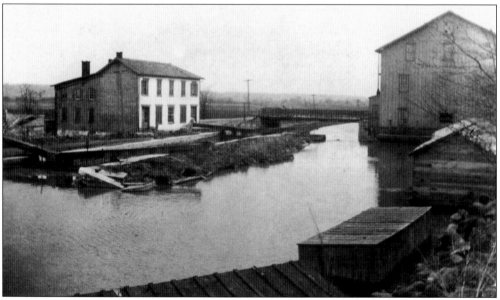

This is one of the earliest photographs of Lock No. 15 on the Miami and Erie Canal. It does not look like much, but it would be the birthplace of Tippecanoe. To the right is the gristmill built by the Johns brothers. On the left is the Barrienbrock Hotel, which was one of the first brick buildings erected. East Main Street would eventually pass right in front of it.

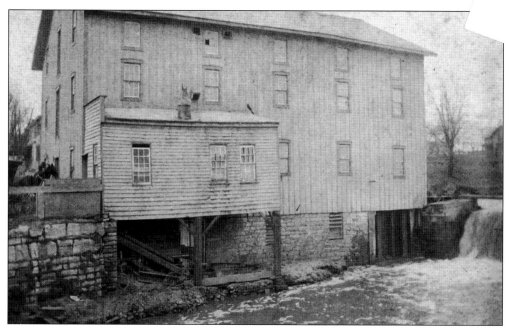

The Johnses' gristmill was the first structure of any importance in Tippecanoe. Uriah Johns obtained canal water rights for 99 years, but later, John Herr cut a channel under Main Street to build a second mill and a flaxseed oil mill using that water. When he sold that mill to Chaffee and Smith, a legal battle over water rights ensued, but the mill retained use of the canal water.

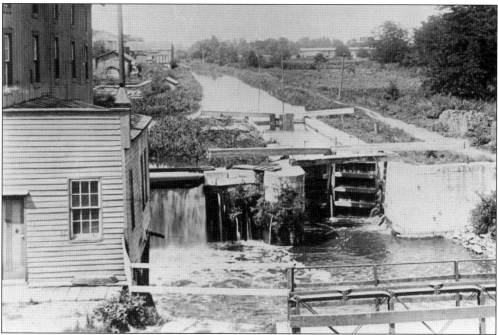

The canal was four feet deep and 40 feet wide with a 10-foot towpath for the mules to pull the boats at a top speed of four miles per hour. The Johns Mill on the left was once the home of nationally known Snoball Flour, and today, it is occupied by the Roller Mill Theater, which features old-fashioned entertainment on weekends in the summer.

November 29th 1834

Received of John G. ...

$7..70 cents to ...

December 15th 16th & 18th 1834
Uriah Johns Dr by boarding
two work hands 10 meals — 0.59

whole amot boarding 83

April 1st 1835
Received of Uriah Johns
for canal timber 15

April 10th Uriah Johns Dr by 4 meals — 23¾

December 1835 James Johns Dr
by 22 meals boarding
by 4 heads cabbage at 3 cts

May 18th 1835
Samuel McFlin Dr by
bushels corn at 50 cts per bushel

Robert Evans was not only a farmer, but also a storekeeper who realized that the area's growing population needed supplies. This ledger page shows that he received $15 from Uriah Johns for timber to build the canal and also charged him 3.5¢ for four heads of cabbage on April 1, 1835. It also shows that Evans boarded and fed several canal workers for five days in December 1835. People could purchase seed, plows, barrels, timber, or even rent a horse to ride the eight miles to Troy for 12.5¢ or the 15 miles to Piqua for 24¢. The book also includes a recipe for killing tapeworms, involving the mixing of vinegar with an assortment of herbs and some penny nails, then cooking it, cooling it, and drinking it. This concoction was sure to kill the worms, if it did not kill the drinker first.

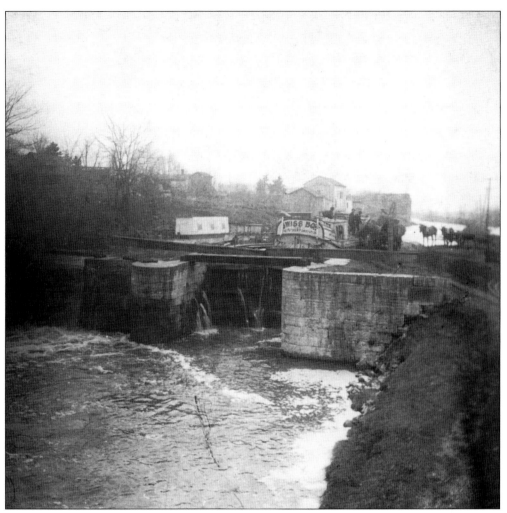

In 1860, men load the *Swiss Boy* at Lock No. 15. The cost of freight was 2¢ per mile per ton, while passenger fees were the same per rider. A canal boat was considered a luxury ride, with hammocks for sleeping and gourmet chefs to prepare meals. Travelers could enjoy a sunny ride on deck in soft chairs, the only inconvenience being the frequent low bridges when they were forced to scramble inside, taking their chairs with them, to avoid being scraped into the water. Another drawback to the first-class ride was that when the mules were not pulling the boat, they rested on the deck alongside the passengers. Sometimes, entertainment was provided when two boats arrived at the lock at the same time from different directions. Official rules had been set for such times, but the usual method for deciding who went first was to have the crews fight it out bare-fisted. Crewmembers were hard-drinking and hard-swearing and were often chosen more for their fighting ability than their boatmanship.

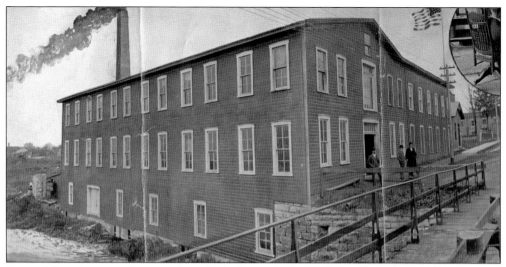

Located directly across the street from the lock was the linseed oil mill. Around 1844, a gristmill was added, and a channel was cut from the canal to power the mill. After the mill was destroyed by fire in 1883, it was converted into the Tipp Whip Company to make buggy whips. Today, it is an antique and refinishing shop called Buggy Whip Antiques.

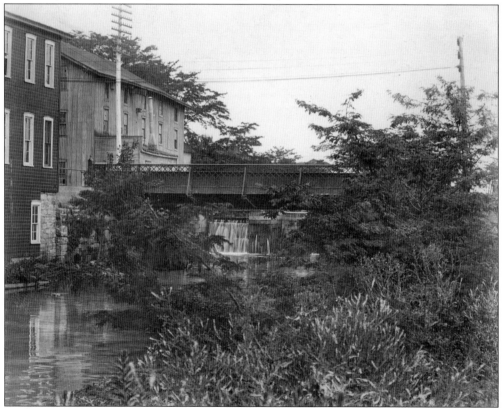

To the left are the Johns Mill, which later was sold to John Herr, and the second mill that Herr built across the street. Notice the iron bridge. It crossed over the canal on Main Street, and if it could talk, it would tell of murder (see page 105).

The Miami and Erie Canal was completed in 1845, but very soon afterwards, it was forced to compete with the faster and more efficient railroad. In Tippecanoe, the railroad tracks are just five blocks west of the canal. These views of the canal north and south of the lock show that as use of the waterway was curtailed, so was the maintenance and upkeep. By 1861, private companies could lease the waterway for their own use for $20,075 a year, but the canal continued to deteriorate rapidly. By the early 1900s, there was very little traffic, but it was not officially drained and closed until 1929.

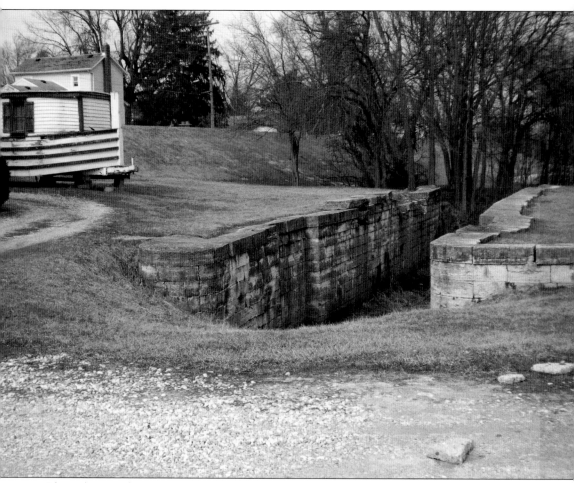

This is how Lock No. 15 looks today, and it is one of the few locks left intact on the Miami and Erie Canal. Of the original 250 miles of waterway, only about 75 miles of land still belong to the state, and most of those plots are less than an acre in size. Working with local community groups, the Ohio Department of Natural Resources hopes to preserve more of this significant part of Ohio's history. In Miami County, a newly completed bike path traces the route of the canal. Located behind the Roller Mill in this photograph is an original, but yet to be restored, canal packet (boat).

Two

MAIN STREET

Tipp City's downtown Main Street is a four-block-long district, where its nearly 200-year history mingles with a wide variety of present-day antique shops, unique stores, and eating experiences. Shops have come and gone, only to be replaced by others, and all thanks to modern-day pioneers, who know that Tippecanoe is a good place to do business and a great place to raise a family. Main Street Tipp City may look a little different from the Tippecanoe of yesteryear, but its heart is still the same.

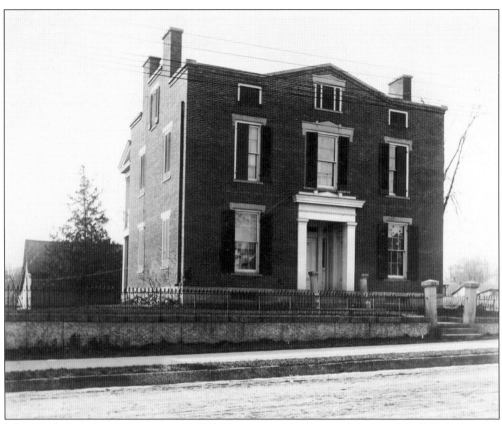

John Clark, founder of Tippecanoe, built his house one block west of the canal in 1850, fashioning it after the Maryland governor's mansion. He decreed there would be no log cabins within the town limits because he wanted a high-class town, not like little Hyattsville next door. A unique feature of his home, and quite a luxury for the times, was a dumbwaiter that carried food from the basement kitchen to the upstairs dining room. Clark died in 1857, just seven years after building this mansion, but his descendants owned the property until it was sold to the Fraternal Order of Eagles in 1937. Notice the tall windows on all sides of the house. Their purpose was to let in as much air as possible during hot Ohio summers, but in these days of modern, central air conditioning and heating, they let in too much air, and an addition has covered over most of them.

William Hergenrether bought this property across from the Clark house on First and Main Streets in 1860 from Henry Krise who had owned it as a tavern and store since 1840. Hergenrether lived there for 80 years and ran a wet grocery. In the early 1940s, James Huffman established a creamery, which was eventually sold to Sander's Dairy. The building was razed in 1976; the area became the parking lot for the Eagles.

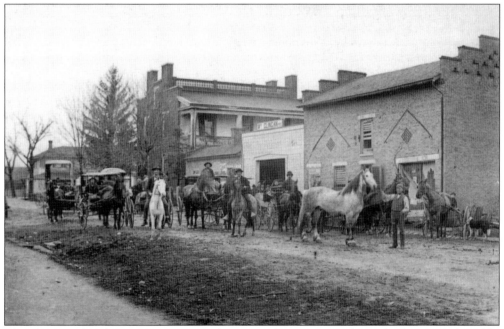

This photograph, taken on First Street looking toward Main Street, shows the former Clark Stable, which became the Clingan Stable in the 1890s. The back of John Clark's mansion can be seen, as well as Hergenrether's store across the street. This stable burned to the ground in December 1913. (Courtesy of Ester Bohart.)

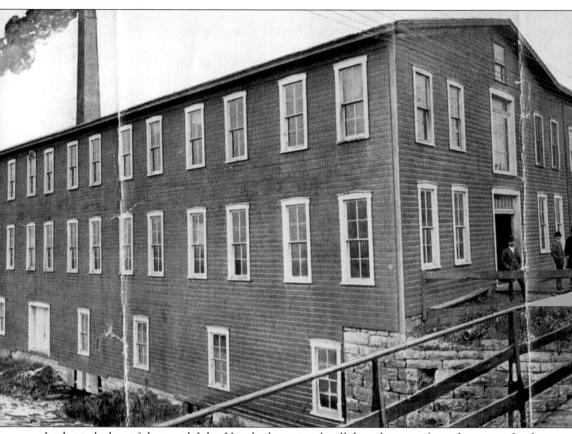

In the early days of the canal, John Herr built a second mill directly across from the one on Lock No. 15. Much litigation resulted when he cut a race (channel) from the canal to the west side of the Herr Mill and then under the street so that the second mill could use the water. After the linseed oil and gristmill burned down, it reopened in 1883 as the Tipp Whip Factory, making buggy whips, and gradually it made the switch from water-driven power to that of the steam engine. After the 1913 flood, the site was declared to be on the flood plain, so Tipp Whip merged with Davis Whip and moved to Second Street, where buggy whips continued to be big business until the advent of the automobile. Later, thanks to James Scheip, the industry turned to making smaller novelty whips for fairs and carnivals. One big customer was the St. Louis Zoo, and when the zoo stopped handling whips as souvenirs because the liability insurance was too high, the whip business finally left Tippecanoe for good.

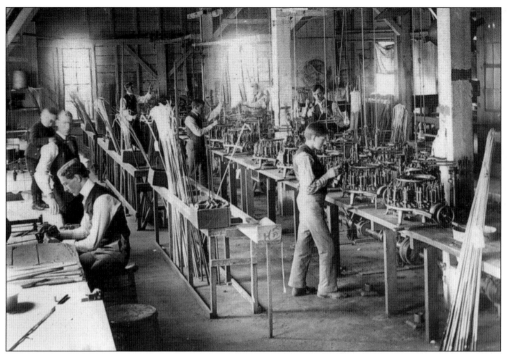

Workers at the Tipp Whip Factory are dressed in high-collared shirts, vests, and trousers.

This photograph was labeled "A salesman's outfit." The whip case above the wheel on this model A Ford is an ironic sign of the end of horse-and-buggy days and the dawning of the new age of the automobile.

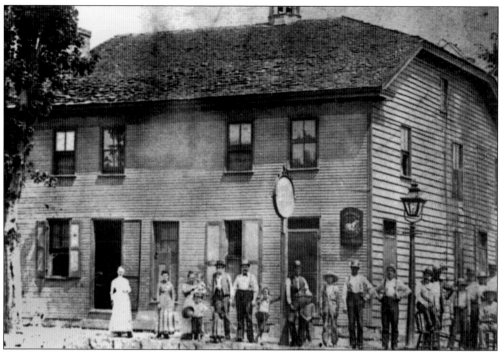

The first lot purchased from John Clark in Tippecanoe is on the northwest corner at First and Main Streets. It was bought by Thomas Jay in 1839 where he built a grocery. In 1848, it became the Exchange Hotel and later, the Henn House, owned by John Henn. In the rear was a dance hall; Bernard Byrkett won $5 for naming it the Chic. Get it? Chic[k] and Henn House.

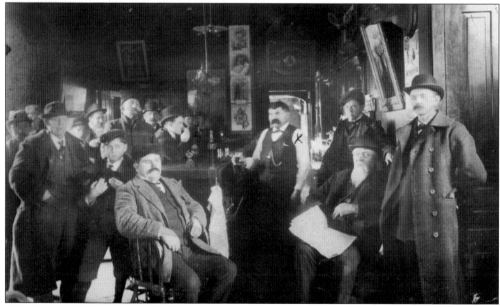

These men are enjoying beer and fellowship at the Henn House. Electric lights indicate it was sometime after 1898, when electricity was introduced to Tippecanoe. Minnie Henn sold a terrific meatloaf sandwich for 5¢, and with a Coke, it was a meal for 10¢. That 10¢ also entitled women to dance at the Chic for free. The man with the "X" on his sleeve is Charlie Henn.

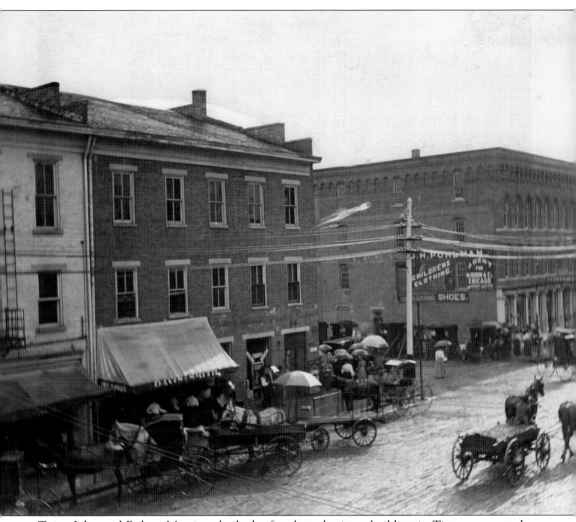

Twins John and Robert Morrison built the first large business building in Tippecanoe on the corner of Main and Second Streets in 1854. This early 1900s photograph shows that Market Day in Tippecanoe was busy even in the rain. Not only was it a chance to buy and sell goods, it was also time to catch up on the latest gossip and visit with friends. Concerts were often held in the evenings where couples danced in the street. Over the years, this building housed various dry goods stores and groceries, and it was also the first home of the *Tippecanoe Herald*, which sold yearly subscriptions for $1. In the 1930s, it was a restaurant owned by Louis and Charlie Priller. Later, Patrick Phelan ran Paddy's, and today Harrison's restaurant, named in honor of W.H. Harrison, whose campaign slogan gave Tippecanoe its name, has rejuvenated the space.

This bakery was on the corner of Second and Main Streets. The little boy is Josh Taylor, and the man second from the left with the potbelly and small cap is John Nunlist, who ran the Old Hotel for 48 years until 1925.

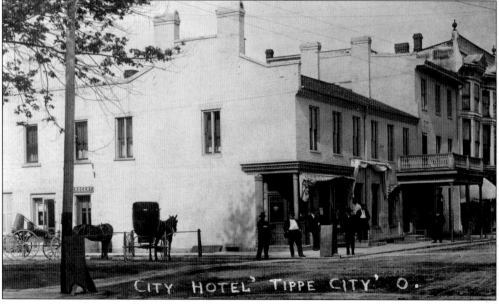

Across the street on the north corner of Main and Second Streets is the Old Hotel. The canal brought many visitors, creating a demand for hotels and taverns. The taller part of the building was the original structure built in 1852, and it was expanded to the corner in 1859. The hotel had 28 rooms with three to six people sharing a bed and only one bathroom.

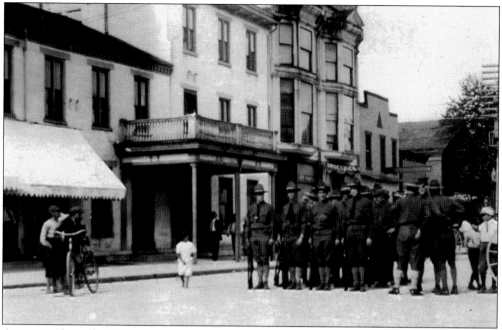

A room in the early 1900s cost 50¢ a night, and the Tippecanoe Historical Museum has one of the original guest sign-in books on display. An awning and a porch were added to the front of the hotel, and a band frequently played under it. These soldiers have gathered for reasons unknown.

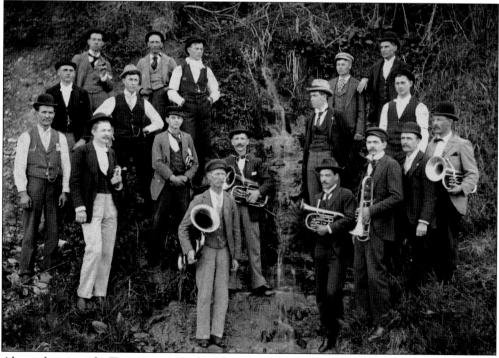

Also at this time, the Tippecanoe City Band was formed. The band put on weekly summer concerts and members were paid in beer or sometimes $1. One of the bass drums was destroyed when a horse stepped on it, but one used later is on display at the Tippecanoe Historical Museum.

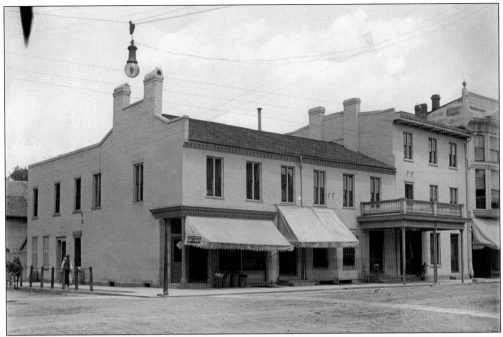

When the Old Hotel was the Carles House, it was a hotel, tavern, and billiard parlor. It was said that many lively billiard matches were held there, during which bets were placed, and the winnings were distributed to needy children and widows. There are doubts about the veracity of this claim, but it makes an interesting story, and it possibly kept the police from arresting the gamblers.

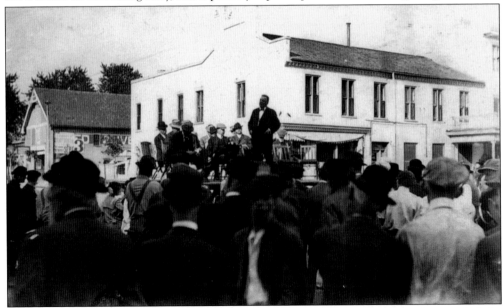

Owner John Nunlist changed the name to City Hotel in 1911. Other businesses have included a cigar store, an optical and jewelry shop, several barbershops, and even an A&P Grocery. During the Depression, Mary Neal ran the Maple Restaurant known as "the best eating place in town." In the 1930s, the corner space became Style's Shoe Store run by Paul and Richard Stiles. Floyd Cunningham is speaking on the bandstand.

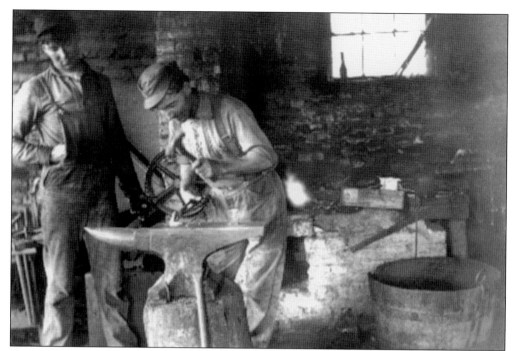

In early Tippecanoe a blacksmith would be very busy repairing wagon wheels and forging various kinds of equipment. Technically, a farrier shod horses, but often a smithy did both jobs. The blacksmith's assistant was a striker whose job was to swing a large sledge hammer in heavy forging operations as directed by the blacksmith. It was a hot, dirty job, but a competent smithy was much in demand.

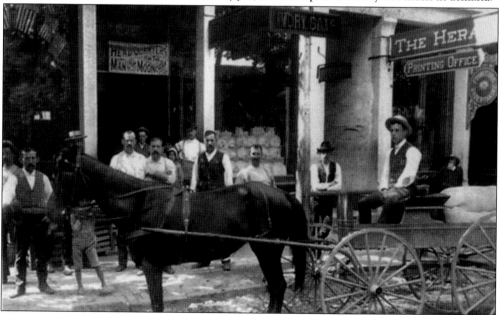

This photograph shows Main Street in front of the office of the weekly newspaper, the *Tippecanoe Herald*, whose slogan was "Your grandfather read it, your father read it, so should you." Often, obituaries and other notices were posted on a bulletin board outside the office to keep people informed between the weekly issues.

These men are standing in front of Dr. Tenney's dentist office. On the back of the photograph, in Grace Kinney's nearly unreadable handwriting, are the names of three of the men, Frank Hollingsworth, Dan Davis, and TenEick—no first name. (Courtesy of Robert Davis.)

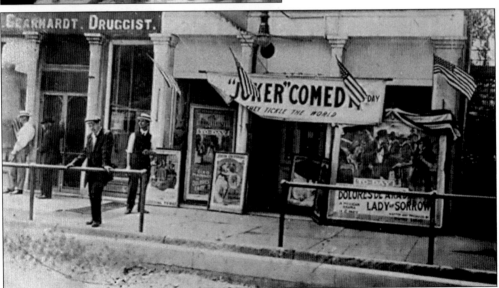

This silent movie theater was a busy place on Main Street in the early 1900s. The sign advertises *Joker's Comedy*, while a poster in the window promotes an upcoming Theda Barrow flick. Tickets cost 5¢ and entitled the holder to spend an entire day watching the movie while local girls played the piano along with the action.

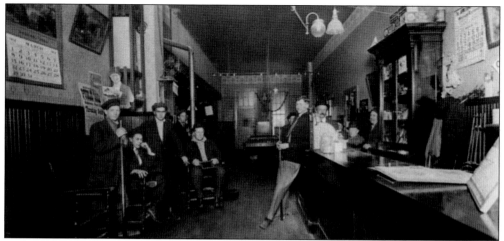

The building at 125 East Main Street was the home to the *Tippecanoe Reflector*, an early newspaper, and to various saloons and restaurants. One called Huber and Oaks served fresh oysters from a barrel out front. Howard "Mutt" Hoover ran the pool hall starting in 1914. Mutt is leaning against the bar. By 1925, this recreational parlor advertised bowling with two lanes, billiards, and a luncheonette.

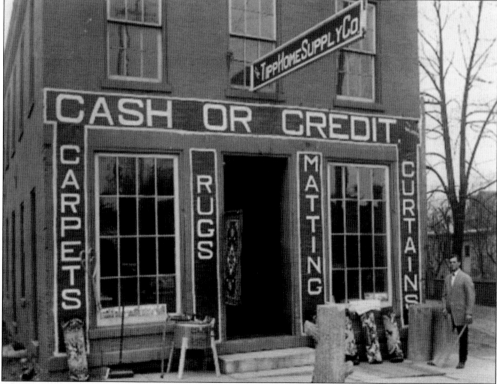

This was once the coal office alongside the railroad tracks, where freight cars dumped coal into the elevator next to the tracks. Then, large scales weighed the coal-filled trucks to determine how much customers purchased to heat their homes. By 1910, Ben Detrick was bottling distilled products in the building. It was later occupied by Kilpatrick Heating and Cooling and is now a cabinet and kitchen store.

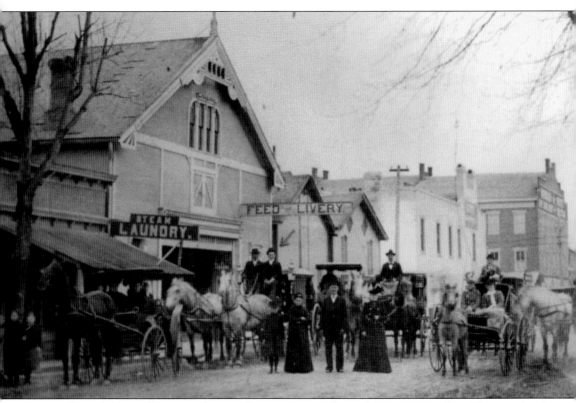

In the early days of photography, people were eager to have their pictures taken. The people of Tippecanoe came out for this photograph taken on Second Street behind the Old Hotel around 1898. The hotel and the Morrison Building can be seen in the background. The Feed and Livery on the left was at one time quite a high-class place to board a horse, with its maple and oak stalls and dedicated staff. It later became a car garage and at one time was home to the *Tippecanoe Herald*. The steam laundry building no longer exists, and the man with the arrow pointing at him is unidentified.

Located on the north side of Main Street between Second and Third Streets is what was known as the Timmer Building, named after Gerhart Timmer, who had it built. Like many buildings in Tippecanoe, its use evolved with the times. It has been home to a Kroger grocery, Benheiser's Drugstore, the phone company, and a bank, and it is currently the home of Cold Water Café.

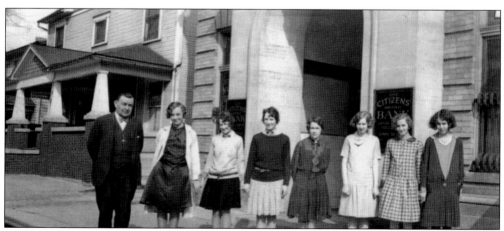

The staff of the Tipp Telephone Company, housed on the second floor, is pictured on April 4, 1929. The phone company first employed teenage boys as operators, but their rambunctious temperaments were soon found unsuitable. From left to right, John Yount supervised Edna J. Magel Deem, Martha Jane Orr Kessler, Betty Keyton Cooper, Daisy Etter Layton, Miss Wintrow, Dorothy Wintrow, and Constance Hess Macy.

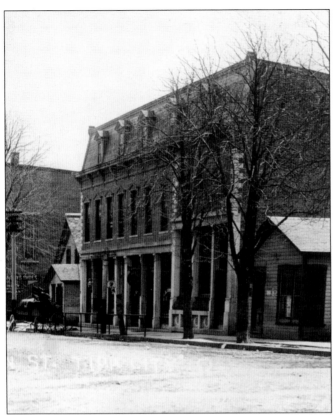

At 14 East Main in 1900, a grocery store shared this building with Coppock & Lee Furniture and the Tipp National Bank. Coppock & Lee were furniture-store owners, undertakers, and embalmers. These businesses often went hand-in-hand because if a company was equipped to build furniture, it could just as easily build coffins.

This was one of the millinery hat shops in Tippecanoe. When hats were all the rage, Tippecanoe had four or five millinery shops, and ladies had a large selection from which to choose.

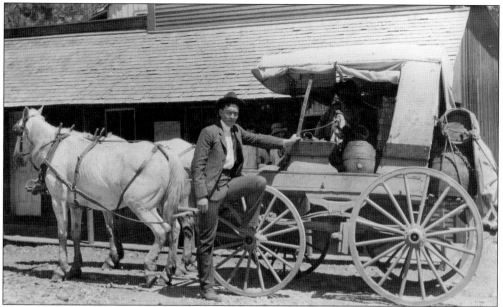

Sometimes stores were portable as was this merchant and his traveling wagon. The barrel and bucket on the back probably held grain to feed the horses while the boxes inside carried his wares for sale.

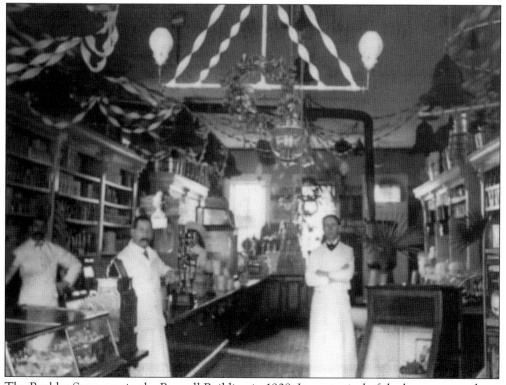

The Buckles Store was in the Burwell Building in 1908. It was typical of the long, narrow shops that were filled to the rafters with merchandise. Books line the shelves on the left, and it looks like pastries and candy are in the glass display case.

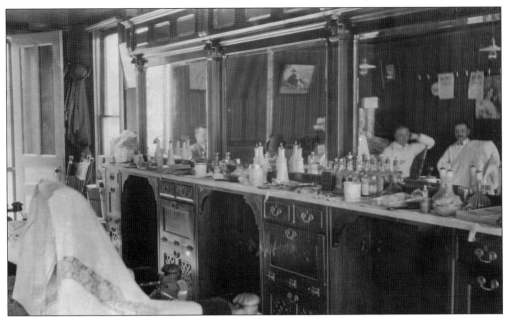

There were barbershops aplenty in Tippecanoe like Schram's. The lull in business shown here was unusual. Men went to the barber on a regular basis for haircuts and often a shave. The shops were also popular places for men to visit and catch up on the news and goings-on around town.

From left to right, Garfield Baldwin, Conrad "Cooney" Bowmaster, Leslie Eickhoff, and Tom Herring posed in front of their barbershop where Monroe Federal Bank is now. Cooney lost a leg while jumping onto a freight car and was famous for his wooden one. None of the shops took appointments so customers opened the door and asked, "How many ahead?" The answer determined whether they stayed or came back later for a 35¢ haircut.

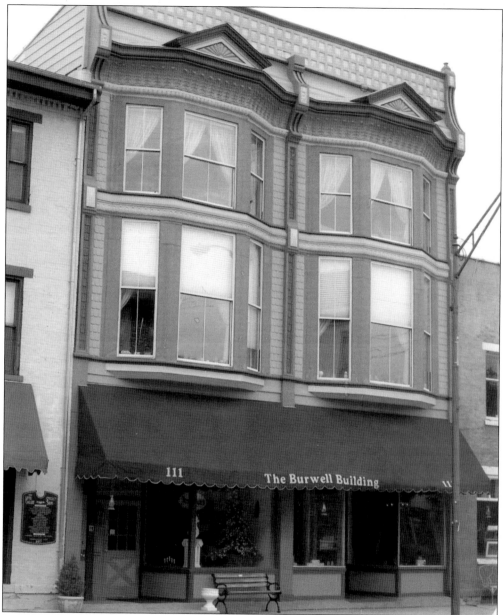

In 1880, John Burwell designed and built this house for his artist-photographer son Ralph, an 1899 graduate of Tippecanoe High School. A unique feature is a skylight located above the hallways, which gives each upper room light. Ralph's many glass negatives are stored at the Tippecanoe Historical Museum. He never married and lived in the upper two floors. In the winters, he spent much of his day at the public library because for many years, his apartment had no heat or toilet facilities. Betty Barnhart Eickhoff remembers Ralph teaching several children about stamp collecting on Sunday afternoons. After their lesson, Ralph's mother would serve them hot tea and a cookie. In 1898, a grocery called Gibbon's Confectionery did business on the street level in the east room with a millinery in the west room. In 1911, the millinery became a music store, run by Preston Miller, who also sold wallpaper, and 10 years later, M.B. Hines opened a grocery store in the space.

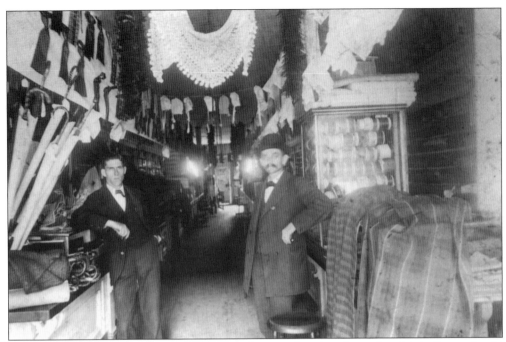

Edward Timmer and Wilhelm Koetitz are standing inside a shop located on Main Street. It sold fabric and thread, among other things.

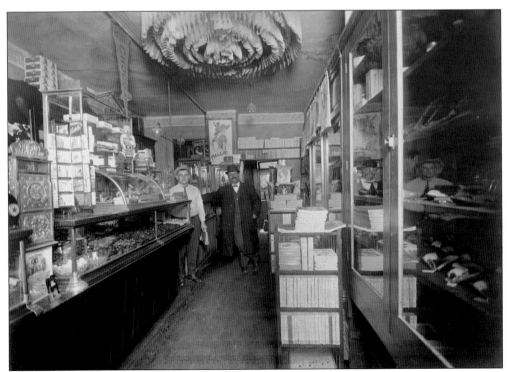

In 1910, this was Smith's News Stand and Confectionery in the Honey Kopp room. J.A. Smith was the proprietor. Arthur Cost was the clerk.

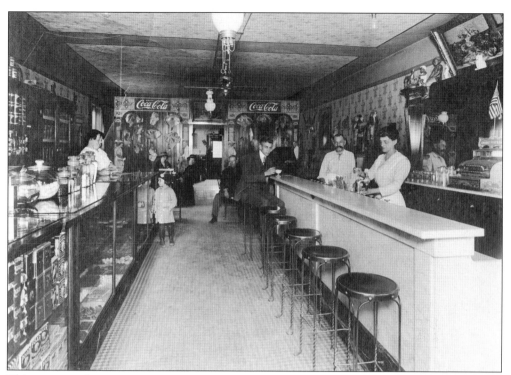

This space on the corner of Main and First Streets was first owned by Ott and Mett King. It later became Blackie's Blue Bird Tea Room, often called "Blackie's." A favorite treat was the bittersweet sundae, but ordering a hamburger was risky because "You had to be brave enough not to care about the cockroaches in plain sight sometimes found in the peanut jar."

In May 1925, this advertisement featured "dopes," which was the common name for syrups or toppings on ice cream at the time.

Ice Cream Soda

Cool and refreshing on summer days. All flavors with Red Wing ice cream and "snappy" soda water.

Dopes and Sundaes

Many delicious combinations in ices with fruit syrups, nuts and marshmallow creme.

Keyton's

May 192

"The Best Sodas in Town"

37

Phone for Food
It is the Better Way

COFFEE IS REALLY CHEAPER

Last week the coffee salesmen quoted cheaper wholesale prices. We at once gave our patrons the benefit of this five cent cut, even on the coffee we have on hand.

STRAWBERRY PIE

Sprinkle 3 heaping teaspoonsful Minute Tapioca into bottom of crust. Add one quart of berries. Cover berries with 2 egg yolks, 1½ cups sugar, ¼ teaspoonful salt well mixed. Bake rather slowly. Add ½ cup powdered sugar to the two beaten egg whites and cover pie when done.

MAY 1925

Brubaker & Poock

Brubaker and Poock Grocery offered coffee and pot roast at terrific prices. With a lack of refrigeration, people shopped nearly daily, buying only what they needed, keeping it cold in an icebox. It was the modern refrigerator that finally brought electricity to Tippecanoe seven days a week. Before that, power was on all day only on Mondays for washday and in the evenings.

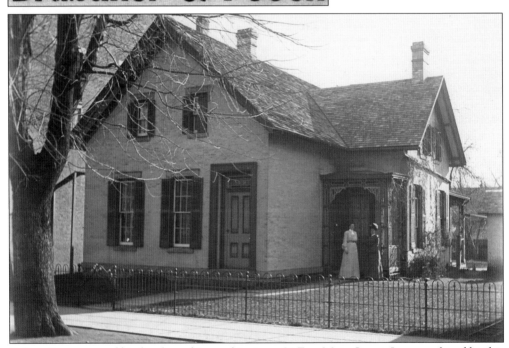

Robert Evans erected his first log cabin on this site at 24 East Main Street. It was replaced by this Victorian home, owned by Edgar Franklin in 1905. Pictured are Myra Franklin and Gertrude Itley Currie. Later, the site was home to a barbershop and Ruth Sprecher's Beauty Shop, until it was torn down in 1962 to make way for the Monroe Federal Savings and Loan.

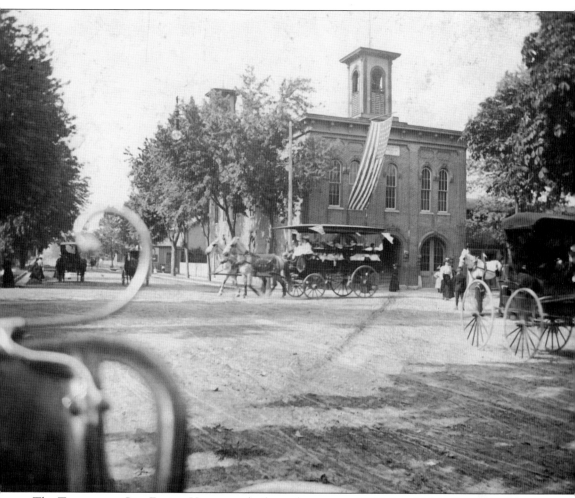

The Tippecanoe City Engine House was built on the corner of Third and Main Streets, on the former site of the village smithy, by Charles Trupp in 1874 for $5,939. It is most often referred to simply as the "city building" because it has, along with the fire engines, the town hall, the calaboose (jail), the post office, the first public library, and a basketball facility. During the canal days, a special fund had to be set aside for repairs to the calaboose. Arresting drunken canal men was often pointless, because their friends would set them free the next morning by tying ropes to the bars and pulling the bars out with horses. At one time, the calaboose was "the best maintained building in town." Featured in the center of this photograph is Bill Clingan's Tally Ho, a pleasure wagon pulled by horses.

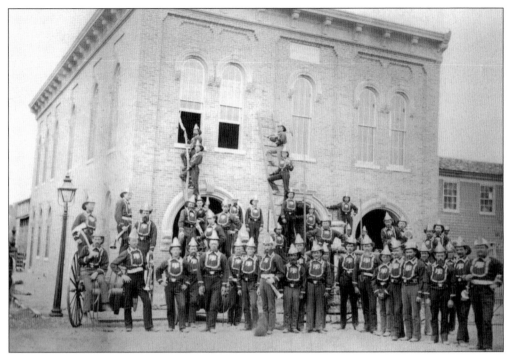

The volunteer firefighters of 1875 posed in front of the Engine House in their new uniforms for which the council paid $532.92. Notice the nickel trumpets held by two men in the front row. The trumpets signaled firefighters between the seven wells that pumped water from the canal at the end of each street. The well at Dow and Fifth Streets was 25 feet in diameter.

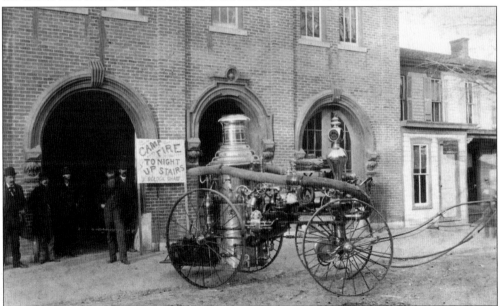

If a horse was not available, any able-bodied man within hearing distance of the call was required by law to come pull this fire wagon. The wagon and the ability to pump water from the street wells greatly aided the men in quickly extinguishing fires. It was the frequent distillery fires that prompted organizing a fire department in the first place.

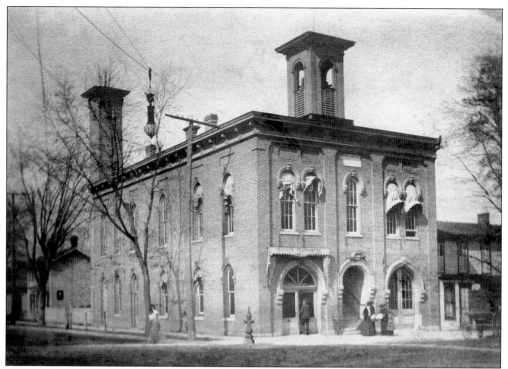

A fire bell was installed on the roof in 1878. Foldable awnings were added to the windows along with a tower on the roof for drying the fire hoses. The fire bell also alerted people to natural disasters such as the flood of 1913. The bell has since been moved to the city park, and the fire station is now located on Main Street near Hyatt Street.

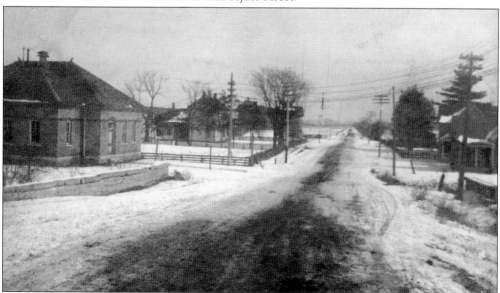

This c. 1897 photograph shows the power plant and the houses east of the canal before the flood of 1913 on land known as Clark's Island. These homes were damaged by the floodwaters and, later, the land was declared a flood plain. Fourteen of the houses were moved to higher ground, while the power plant was condemned and torn down several years ago. (Courtesy of Dave Reichert.)

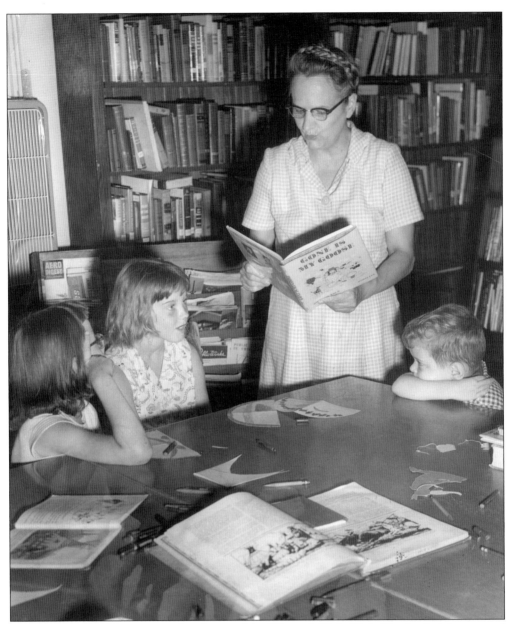

In 1922, the public library was only a dream of the Women's Civic Club. The fundraising opened with a lawn social. There were "beautiful decorations, electric lights, delicious food, and surprise package booths." The band played, cakes were auctioned off, and the "highly successful sum" of $123.26 was raised. Soon, the library board had $1,569.55 in its coffers. Many sites for the library were considered, but finally it was decided to partition off a section on the second floor of the Tippecanoe City Building. Chairs were purchased for 50¢, tables for $1, and donated books were collected during "Shower Week." The library officially opened on June 12, 1923. The first librarians were Lulu Cottingham and Anna Shaffer, who were succeeded in 1949 by Catherine Kessler, shown here reading to some students. From the street, the center stairs led directly upstairs to the library that always smelled of wood and library paste. When the library outgrew the space, a new one was built next door.

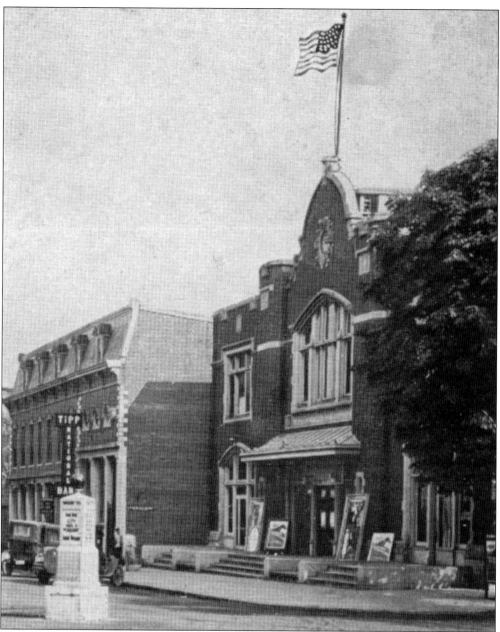

Across the street at 4 East Main Street is the Monroe Township Building, which was built in 1915 and featured a full kitchen in the basement, offices throughout, and an auditorium. High school graduations were held there for nearly 40 years, and movies were shown nightly for 5¢ admittance and later, 25¢. After the Tipp Theater closed, the entire space was remodeled to accommodate businesses such as a bank, dental office, dress shop, and barbershop. The Seth Thomas clock in the front was a gift to the community from the Sidney Chaffee family. Chaffee made his fortune making whiskey, which was once a robust business in Tippecanoe. He also donated the money to build the Chaffee Opera House, which appears in chapter seven. The clock weighs over 300 pounds and is 2.5 feet across. Originally, it had to be wound manually every eight days, but now it is automated. Listen for its chime at noon every day.

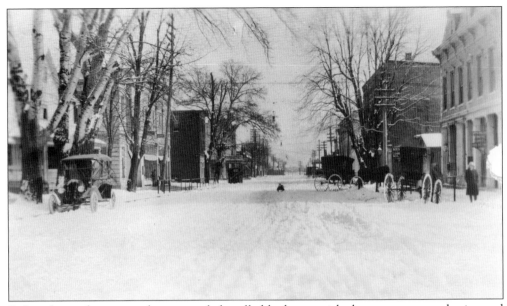

Before the modern snow plow, snow sleds pulled by horses picked up passengers, who jumped on and off as the sled went past their stop. Once the sidewalks were cleared, the sleds stopped running. Notice the large trees that lined the street, which are no longer there. (Courtesy of Loraine Knoop from estate of Opal Cunningham Hand.)

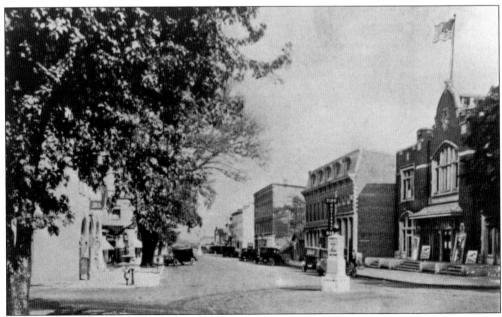

This c. 1920s photograph of Main Street shows automobiles instead of horse-and-buggies. What looks like a gas pump in the middle of the intersection is an early stoplight.

Three

THE PEOPLE
OF TIPPECANOE

It is the people who make history, and while history may record their significant or memorable contributions, quite often very little is known about their everyday lives. What did they like to eat? How close were they to their families? Did they sing as they worked? It may only be through personal journals and the labeling of photographs with names, dates, and places, that their private histories are in any way preserved. While the day-to-day lives of the people in these photographs may be lost, it is interesting to see how they dressed, how they wore their hair, and where they lived. These are all clues to imagining what their lives must have been like.

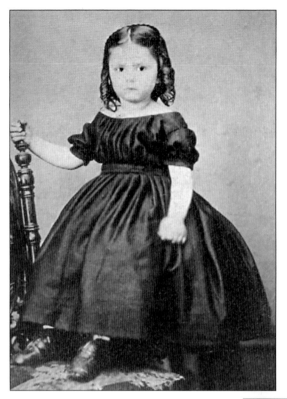

The label on the back of this photograph says only "Mrs. Frank G. Davis, age three." Her first name is not known since married women in this era were typically identified by their husband's name.

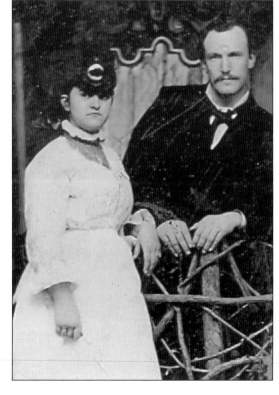

This is the same little girl on her wedding day in 1881. The photograph was labeled simply, "Mr. and Mrs. Frank G. Davis." Her hat was a popular style of the time. Although the couple does not seem too happy, it should be noted that in the early days of photography, it took a long time to take the photograph. A somber expression was easier to maintain.

Eleven years after his wedding, Frank G. Davis, center, posed with these children, possibly his stepchildren from a second marriage or his nephews. The children, from left to right, are Ralph Rainey, Frank Smith, and Frank Rainey.

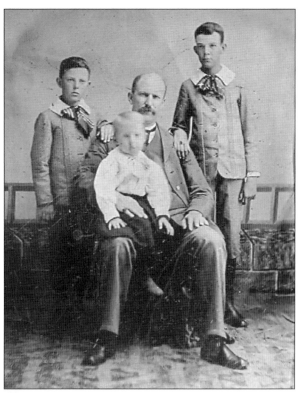

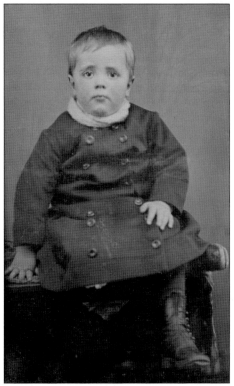

Notice this child's buttonhook shoes and the coat with two rows of buttons. These were both typical dress for the times.

It is hard to tell from the curls and white dress if this is a boy or a girl. Years ago, all young children, boys and girls, wore loose dresses, and a boy's hair was often left to grow long. At age six or seven, a boy could start wearing short pants or knickers. It was not until he was fully grown that he could wear long pants.

These boys in their knickers appear to be around 10 or 11 years old. Hartman Kinney who will be Grace Kinney's future husband is second from the left. The other boys are, from left to right, Ben Harshbarger, Robert Geigler, and Cornell DeWeese.

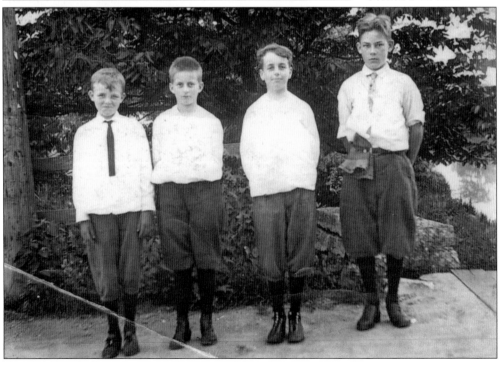

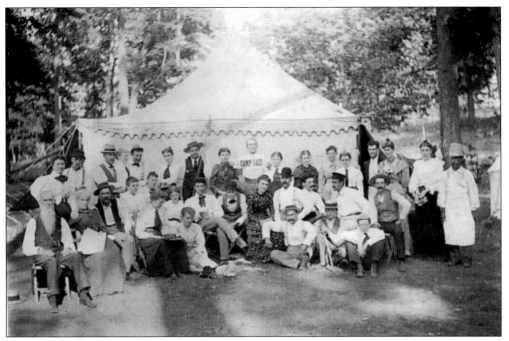

Pictured in 1894, Camp Lazy was located near the Miami River, respite from the heat in the days before air conditioning. The long skirts, white shirts, and vests seem inappropriate for camping but were typical garments of the day.

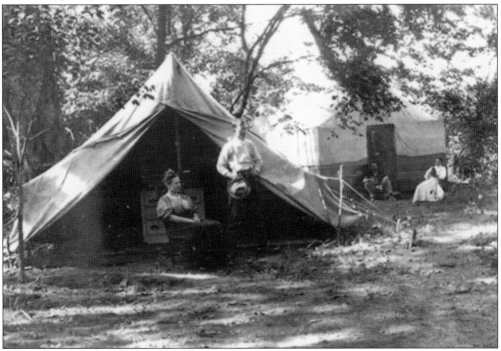

Mary Favorite is sitting in a rocking chair beside her husband, Harry Favorite. Notice the dresser in the tent behind her. Families often brought their beds, mirrors, and tables with them when they camped, along with all their kitchen utensils.

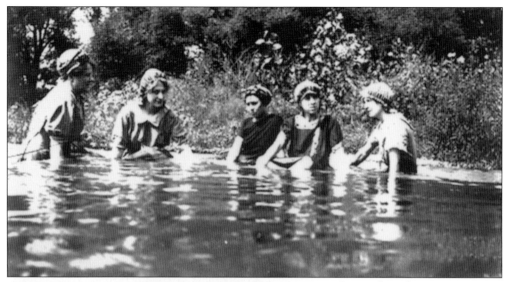

It must have been quite difficult for these bathing beauties to swim in all that heavy clothing, and it is certainly a far cry from the bikinis of today. In this era, women's full names were often not given, especially if they were married. From left to right are Allie, Ethel Hartman, Mrs. Bennett, Mrs. Crane, and Mrs. Hayward.

Pictured from left to right are Ralph Hartley's children: Ralph Jr., known as "Red," Jean, and Richard. The date and their ages at the time are not known.

This is the last photograph taken of
the Mast family together. The children
were orphaned, but no one remembers
how or why. The tall boy in the center,
Henry, was taken in by Thurman and
Maude Fox of Tippecanoe. The other
two boys and the daughter were split
up and sent to live with relatives, but
no one knows where, and the siblings
lost all contact with each other.

Nothing is known about this
photograph except that whatever
they are doing looks like a lot of fun.
It can only be imagined why they
are wearing little hats and holding
balloons. The museum has numerous
pictures of these couples together
doing other, but just as silly, things.

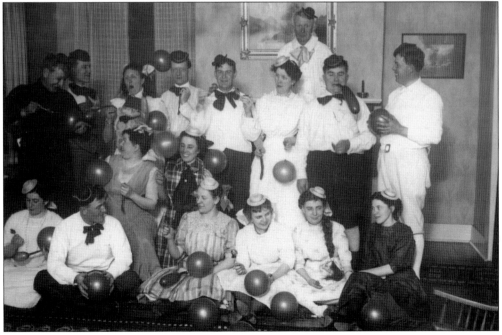

Henry Eickmeyer is on the porch with the surviving eight of his 10 children. The baby in the carriage, Grace, died four months later in August 1884. It was common for children to die young of sickness and accident because of lack of modern medical care. At the time, this house was on the outskirts of Tippecanoe on land formerly belonging to the Timmer family. (Courtesy of Susie Spitler.)

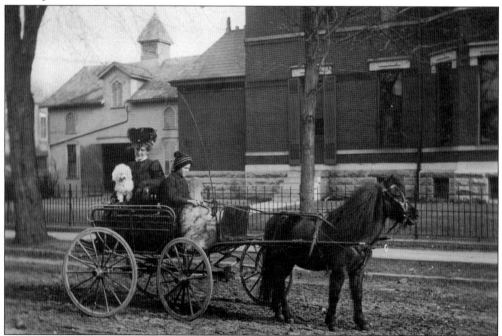

This photograph shows a mother, son, and their little white dog out on a jaunt. The boy is learning how to drive with this small carriage pulled by a pony. Note the fur blanket around his legs and mother's stylish hat.

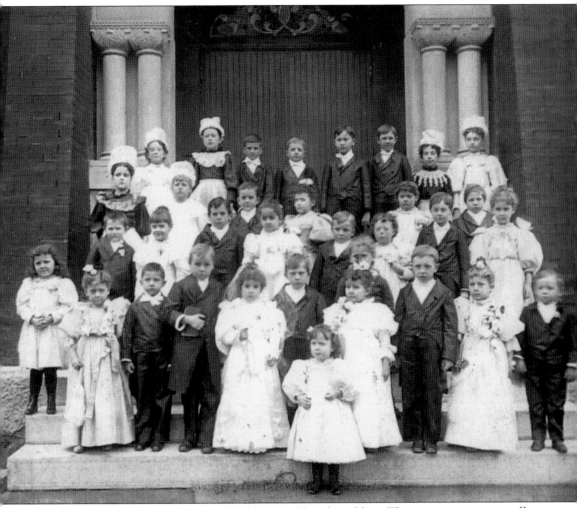

In January 1896, the Lutheran church held a Tom Thumb wedding. These pageants were usually fundraisers. All of the major wedding roles, including bride, groom, attendants, and sometimes the minister, were played by young children usually under the age of 10. Scripts were available, and often a professional Tom Thumb Wedding coordinator was paid to come in and run the event. All the children were costumed, and many photographs were taken. These pageants were named for the lavish wedding of two little people in 1863, Charles Stratton, who was titled General Tom Thumb by P.T. Barnum, and Lavinia Warren. During the reception, the couple stood on a grand piano to greet their many guests, and afterwards they were received by President Lincoln at the White House.

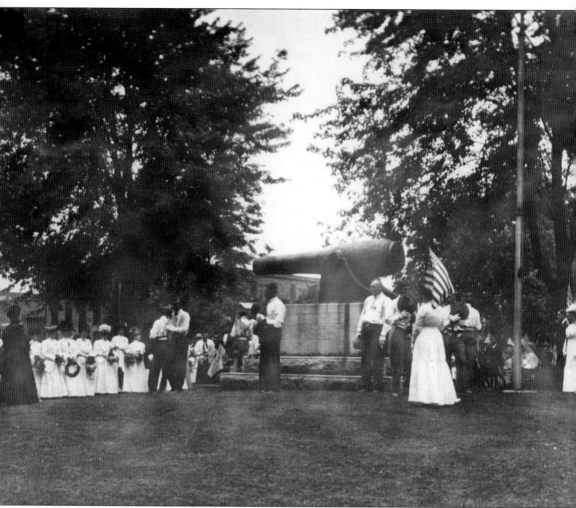

This photograph was taken on Memorial Day 1911 on the corner of Broadway and Fifth Streets. The cannon in the center has engravings on three sides that tell its story: "Grand Army of the Republic 1861 Veterans 1865," "To the memory of the soldiers and sailors that served in the army during the Civil War from 1861–1865," and "Erected by D.M. Rouzer Post G.A.R. and presented by them to the citizens July 4, 1904." The Grand Army of the Republic was a fraternal organization of Civil War veterans. The cannon weighed nine tons and required five teams of horses to pull it into position, and still, the wagon sunk into the mud. In 1952, a gym and elementary school were added to the site, and the cannon was moved to the American Legion building on Third Street.

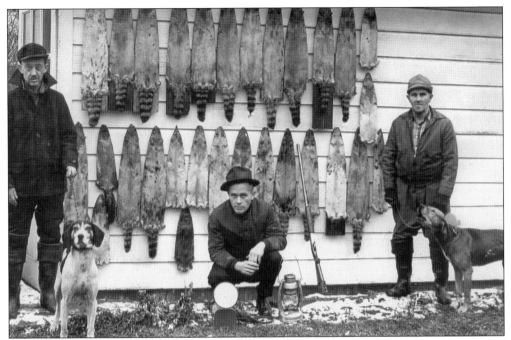

Coon hunting was once a popular nighttime activity around Tippecanoe because skins were in demand for fashionable stoles and hats. These coon hunters are showing off their successful hunt by drying the coonskins on the garage wall. (Courtesy of Dr. Martin English.)

The two coon dogs look ready to go. They have been trained to follow the raccoon's scent through brush, trees, and debris. The scent is strongest when the area is wet, so the best time to hunt is on damp humid nights or in swampy areas, of which there used to be many around Tippecanoe. (Courtesy of Betty Eickhoff.)

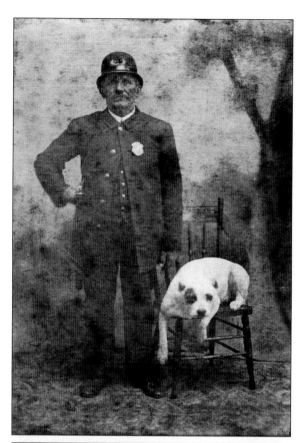

"No one ever scared me yet," says Chris Eickhoff, night policeman in Tippecanoe. Crooks give the town a wide berth. Once he chased a thief over six miles. The man had a gun and a wicked knife, but Eickhoff just laughed and disarmed him. Another time, thieves gave him a merry chase through the swamps, but he marched them back at the muzzle of his gun. (Courtesy of Betty Eickhoff.)

H.W. Christian "Chris" Eickhoff (seated) emigrated from Germany as a teenager, married, and raised his family in Tippecanoe. Chris was so well thought of as a policeman that the businesses in town paid him extra to check their shops every night in addition to his police salary. The youngest boy is Leslie Eickhoff, the future barber. (Courtesy of Betty Eickhoff.)

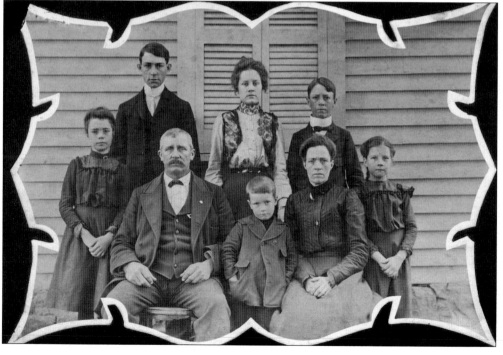

The Doubledee musical team traveled around the area, bringing music to churches and other performing events.

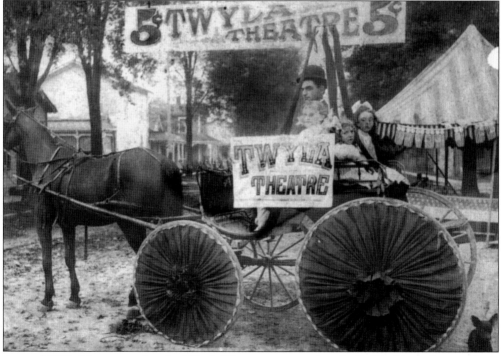

Around 1910, this wagon advertised Twyla Theatre presentations for 5¢. Nothing is known about the presentations, except that Margaret Eickmeyer and friends were offered the chance to dress up and ride through Tippecanoe. (Courtesy of Susie Spitler.)

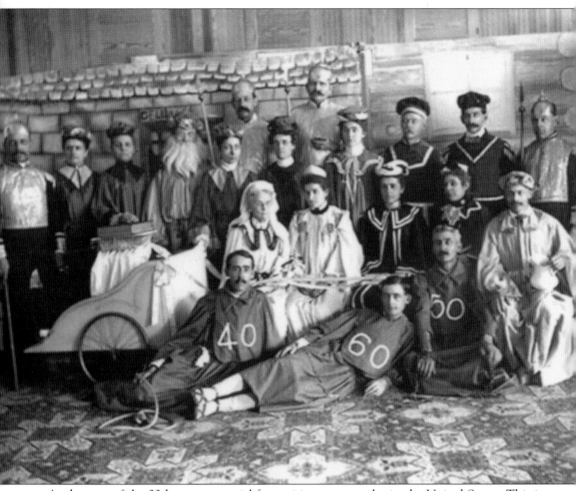

At the turn of the 20th century, social fraternities were popular in the United States. This is the Degree Team of Iras Court, Tribe of Ben Hur, Tipp City. The organization began in Indiana in 1894 and was characterized by exotic initiation rites, elaborate costuming, and theatrical furnishings, which explains the bizarre setting shown here. The Tribe of Ben Hur was unique in that it was an insurance fraternity. In the days of limited opportunities for women to work and before government-supported programs, a man's death could leave his family penniless. Each member made a monthly payment, and the fund paid the family death benefits. Another unusual aspect was that single women were admitted on an equal basis with men. The name of the group was taken from the novel *Ben Hur*, written in the 1860s by Gen. Lew Wallace. David Gerard, the founder of the fraternity, wanted to call it the Knights of Ben Hur, but General Wallace talked him out of it. "There are no knights these days, but there are tribes."

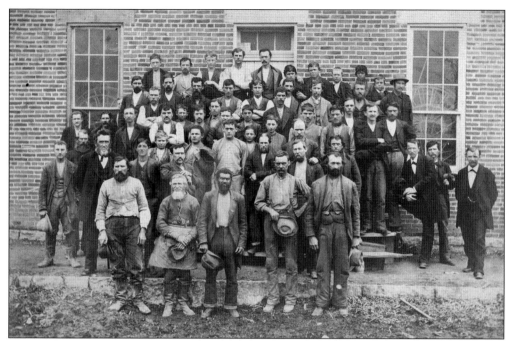

The label on the back of this company photograph of the Tippecanoe Wheel Works says it was taken "about 1880—Jeff Motter died in 1882." Motter is in the fourth row, fourth from the right. The man leaning on his leg with his foot on the step is Thomas. J. Sheets, one of the owners. Scattered among the men are several young boys. There were no child labor laws at the time.

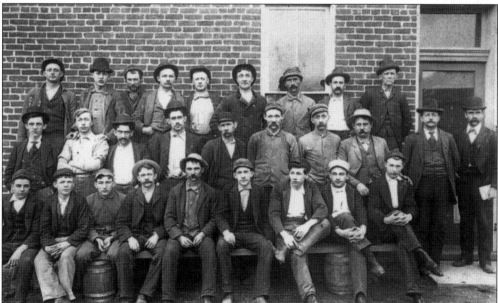

The employees of Garver Furniture Factory on South Fifth had their photograph taken sometime in the late 1800s. Garver Furniture made bedroom furniture and operated until 1920 when it was sold to Northern Manufacturing and then to Sun Glow Furniture. Abraham Rueban Garver, the owner and an Ohio senator from 1915–1917, is standing on the far right in a suit and hat with a card in his hand.

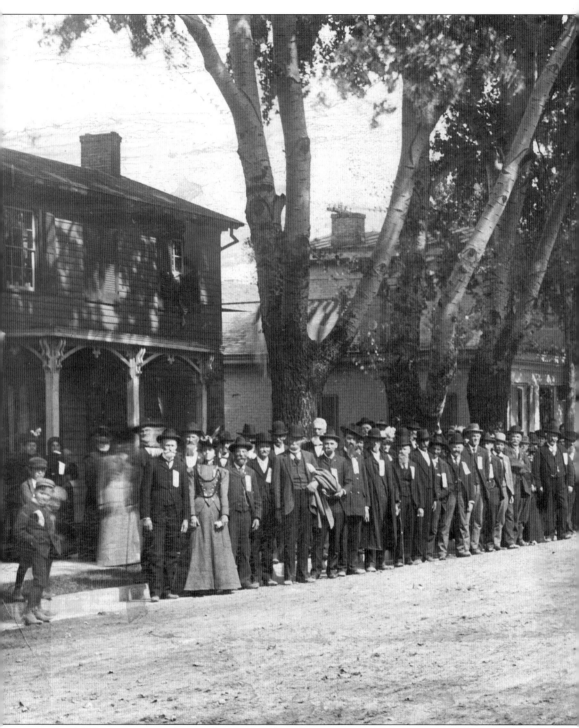

Civil War veterans and their families gathered on Main Street just east of the Tippecanoe City Building. Some of the Civil War veterans from Tippecanoe were Anijah Miles, the clerk, postmaster, and school board member, who was "an absolutely fearless bearer of the flag," having saved the flag from falling at the Battle of Chattanooga. Dr. Abraham Hartman served in the

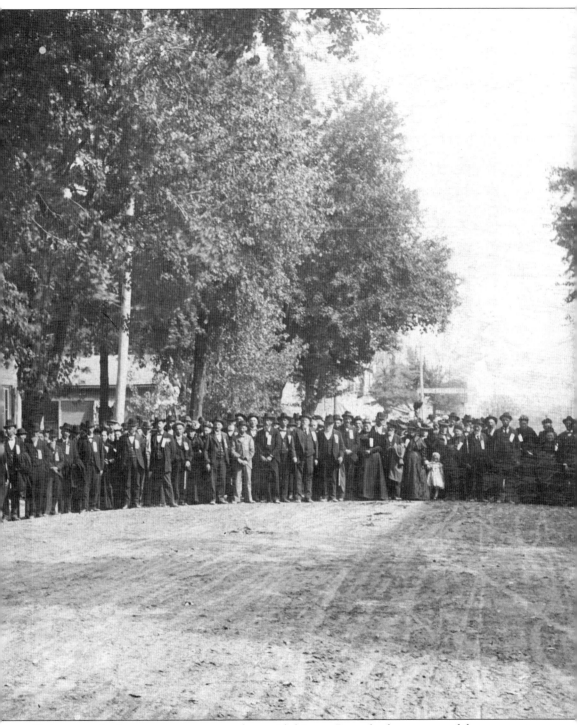

Union army for four years as a surgeon along with his son Samuel, who was one of the youngest from Tippecanoe to enlist. John Clark Jr. and his brothers Mordecai and Levi also fought. A Civil War memoir recorded after an 1862 battle, said, "The first man I met after the battle was a colonel. I asked him, 'Where is the regiment?' His answer was 'All shot to pieces.'"

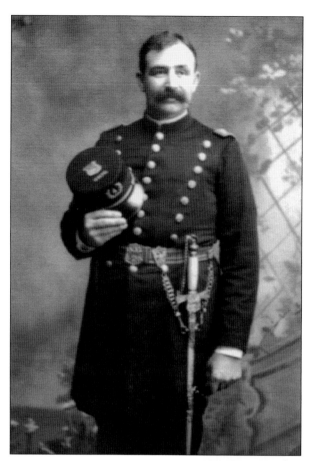

Thomas Hartley, seen here in his uniform, can also be seen in the Civil War reunion photograph on the previous two pages. Look closely near the center of the line. There is a very small child dressed in white and to the right is Hartley with a long white beard. He died in 1901, and he was known as "one of the striking figures of the community. Once seen his face was seldom forgotten."

Thomas Hartley was a successful grain and coal dealer in Tippecanoe. Born in Virginia, he was orphaned at an early age and came to Ohio to work as a farmer. He married Margaret Favorite, and they had 10 children. He enlisted at age 30 during the Civil War, in which he fought heroically for two years. His obituary states that upon his return he "resumed a life of industrious occupation."

No memories of Tippecanoe would be complete without remembering Grace Kinney, shown here as the young wife of Hartman Kinney. Hartman was a safety inspector for Armor Packing with territory in Texas, where he fell in love with and married Grace. But in 1932, during the Great Depression, he lost his job, so they went back to Tippecanoe for a two-week visit and stayed for the rest of their lives.

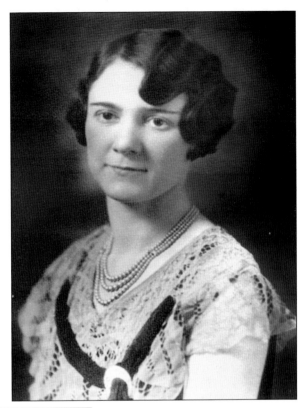

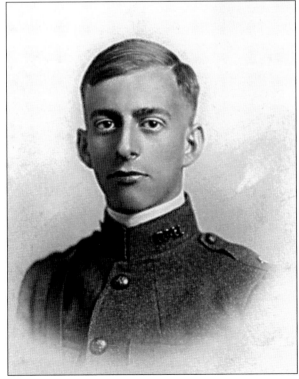

At first, Grace was not enamored with Hartman's (pictured) small hometown, but she commented to a friend, "If I am going to get to like Tipp at all, I must start listening to what people are saying, know who is who, and pay attention to what is happening." She spent her days recording thousands of historical facts about Tippecanoe in her nearly illegible handwriting and equally poor typing skills.

Grace refused to drive, so Hartman drove her to the Miami County Courthouse to do her research nearly every day. She always sat in the back seat and admonished him if he drove over 30 miles per hour. She was known for wearing the little brown hat in this photograph wherever she went, winter or summer. After Hartman's death, she took her supper in local restaurants every night, and she was never without company eager to hear her stories. Although awarded much recognition for her work, she refused to talk if her voice was to be recorded, and seldom allowed her photograph to be taken. Grace said, "Preserving history is like working a jigsaw puzzle. You have to be on the alert at all times for connection of facts . . . and be meticulously accurate. For example, if Tipp had all the Underground Railroad passages I've heard of under this town we would sink to China." This "Away Girl" left behind a legacy that will never be forgotten. Thank you, Grace, for loving Tippecanoe and preserving its remarkable history.

Four

TIPPECANOE HOMES

If these walls could talk, the historic homes in Tippecanoe would have much to tell us about the lives of the people who lived in them. Many of the homes in Tippecanoe are included in the National Register of Historic Places, and each house has its own unique story. Histories have been written for each one, and it is sometimes amazing what is uncovered in the research. Every Christmas during the Christmas Festival and Tour of Homes, selected houses are decorated and opened to the public, and hundreds of visitors enjoy their stately presence. Here are just a few of the treasured houses among those that are still standing and those that are long gone.

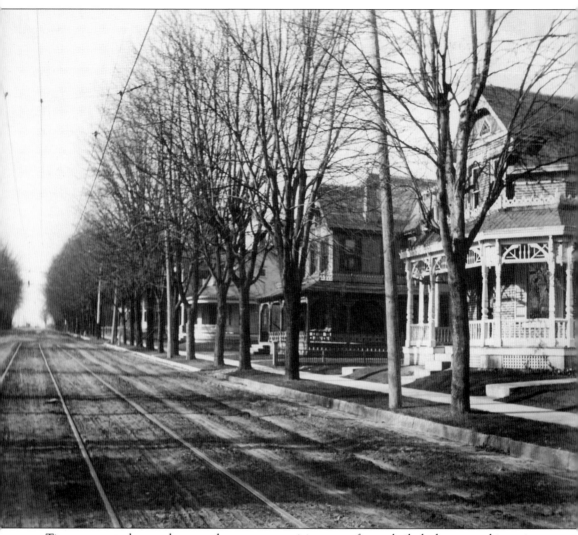

Tippecanoe merchants, who wanted to create a prestigious area of town, built the homes on this section of Main Street west from Fourth Street, across the railroad tracks, and toward Hyatt Street. There are a large variety of styles and designs, but these houses were, and still are, lovingly cared for, and with the advice of the restoration board, retain much of their original architectural character.

Lewis Sheets built this house at 114 West Main Street in 1895 with a goal of making it the tallest and biggest house with the largest porch in Tippecanoe. It had white oak floors—a premium wood at the time—and included servants' quarters with a separate entrance. In the 1930s, Noah and Bertha Yount ran it as a boardinghouse for teachers.

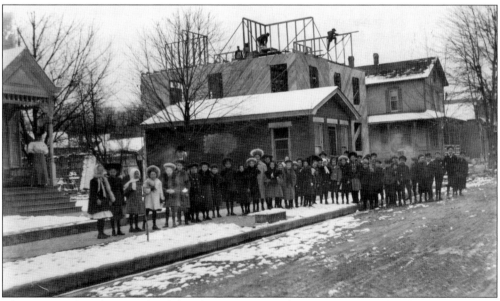

This is an earlier photograph of the Sheets's house under construction. The children posing in front are unidentified.

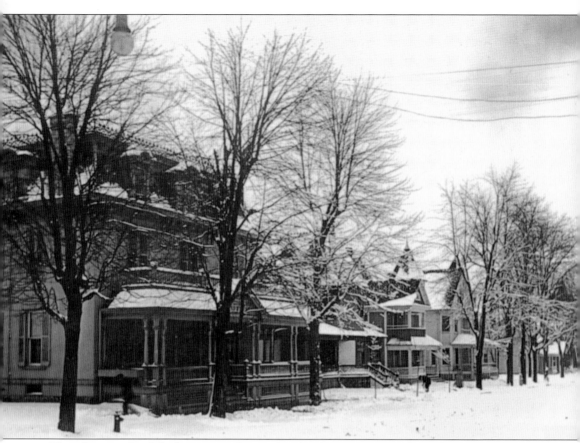

This photograph of the houses on the north side of Main Street is from the turn of the 20th century. The Lutheran church on the next block was built in 1894, and the streets were not yet bricked, which was done in 1913. The first house in the row at 121 West Main is known as the Mattie Crane house and was originally built in 1853 by the Union Theological Seminary. Dr. William Crane, an early Tippecanoe physician, purchased it at a sheriff's sale from the seminary and moved the carriage house that was behind the main house across the street to use as his office. This office can be seen in the previous photograph next to the construction of the Sheets's house. The Crane house features a tiled, gabled roof and an entry that is recessed with wooden pilasters and surrounded by crystal leaded glass panels. The house remained in the Crane family until it was sold sometime around 1980.

At one time, directly to the east of the Crane house, this small house was owned by Dan Smith. It was later torn down, and the larger house in the next photograph was built on the site.

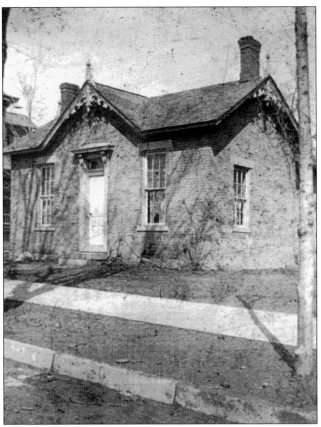

In 1900, Eugenia Smith Wenzlau, upon the death of her husband, built this house at 115 West Main Street. It is one of three Queen Anne homes on the block. This polygonal house features a turret that stretches up three stories. The gable on the attic is covered with fish scale shingles while fan-shaped and rectangular art glass windows can be seen on the right side of the house.

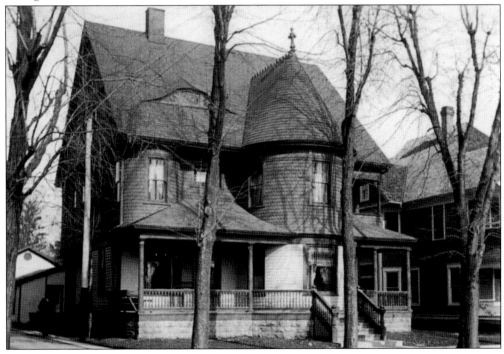

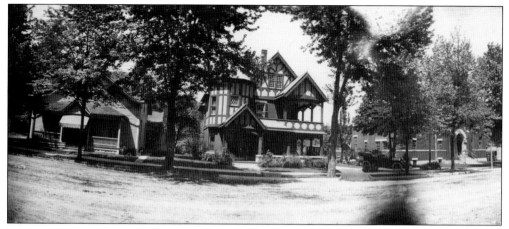

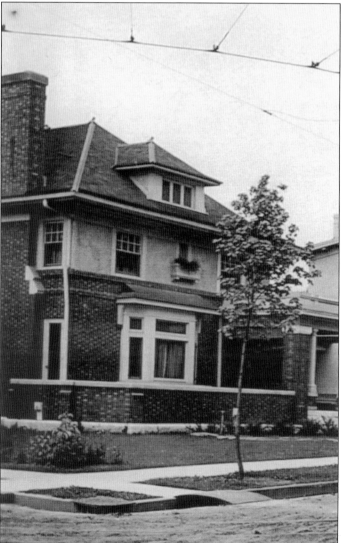

On the left is Daniel Rouzer's house before it was moved to make room for the post office in 1939. To the right is the Lutheran church. The center house belonged to Jake Detrick, who owned luxury cars by Stoddard-Dayton. Their slogan was, "None can go farther. None can go faster," but the $2,000 price could not compete with Ford's $399 Model T, and the company went out of business.

The house on the southwest corner of Main and Fifth Streets was built in 1901 by A.L. Harshbarger, who was influenced by the architecture of Frank Lloyd Wright. Throughout the house are 15 stained-glass windows and four pocket doors. When the house was purchased in 1944, it stipulated in the sale that Harshbarger's widow, lovingly called Aunt Kitty, would stay on and use her bedroom until her death.

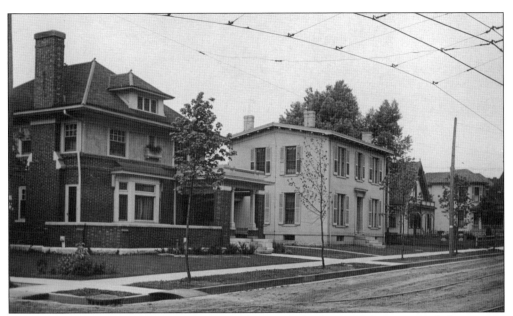

The second house from that corner was built in 1853 by Samuel Morrison, with four rooms downstairs and four matching bedrooms upstairs, each with brick walls on the exterior and interior from the basement to the attic. The original kitchen and laundry were in the basement, and the house was heated by two fireplaces and two potbellied stoves. The wires seen overhead on the street are for the electric trolley.

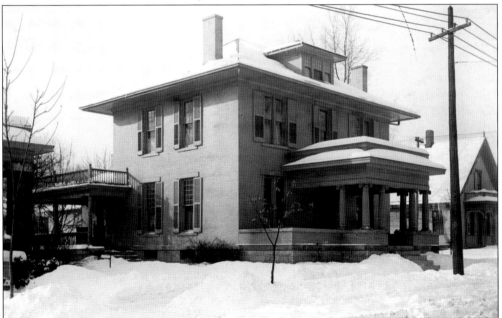

This is the same house in 1910, after the addition of porches on the front and side and a reconstructed roof. Over the years, the electricity, plumbing, and furnace have been updated, but the original carriage house still stands on the back of the property. At one time, the house was mistakenly thought to have been part of the Underground Railroad, which in reality did not go through town.

Lillie Eickmeyer is standing on the porch of her home at 118 North Fourth Street in 1910. John Clark originally owned the lot, which he sold to Dr. H.H. Darst, who built this house in 1865. It was owned in turn by J.W. Bowman, Thomas Hartley, Henry Eickmeyer, and DeWitt Thurman "Chiney" Fox. Traffic accidents took the lives of two of the owners. Henry Eickmeyer, husband of Lillie, was killed in 1933 when he was struck by a car while walking to the Cabinet Works for a night shift. DeWitt Fox's widow, Margaret, wrote of the house, "I'm living here and love it. I've lived other places and can be contented most any place, but I'm happier right here in the old home place."

One of the houses that is gone but still remembered belonged to Joseph Max in Hyattsville. Robert Evans sold two acres and 124 square perches to Henry Hyatt in 1832. The deed states that 27 lots were "20 degrees around a stone in the middle of the road from Troy to Dayton and around that same stone on the road from Greenville to Springfield," which is present-day Hyatt and Main Streets.

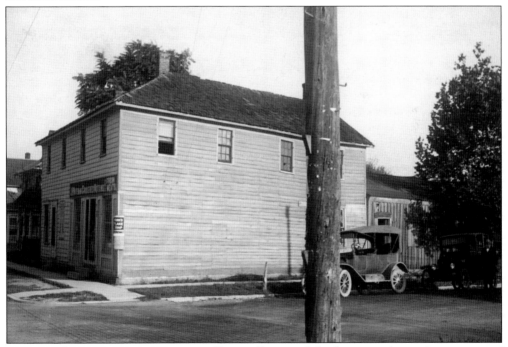

Dr. J.K. Gilbert, one-time postmaster in Hyattsville, owned this house on the southeast corner of Main and Hyatt Streets. It had also been an inn on the stagecoach line from Dayton to Troy and for many years was the Community Grocery. It sold penny candy with cream centers. If anyone found a pink center, a second piece was free. The veterans memorial stands on the site today.

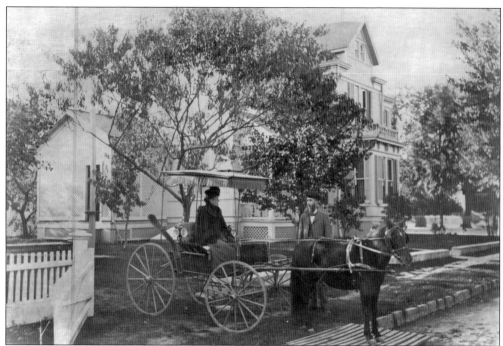

This house belonged to Ahijah Miles, a Civil War hero, who was the first man in Tippecanoe to enlist in 1861. Upon his return, he was active in government, held several prestigious business positions, and was on the school board for more than 40 years. Shown here are Ahijah and his third wife, Ada. His house on the corner of Fourth and Main Streets burned to the ground in 1988.

Robert Evans built a second log cabin on this site on the corner of Third and Main Streets and made it his store. This house was later built on the lot and was owned by Emma "Aunt Meekie" Evans. The gas utility office and a gas station also once stood here, and it is now the parking lot for the Tipp City United Methodist Church.

Descendants of the Herr family, who built the mill by the canal lock, lived in this house on Main Street east of the present-day library. It was moved to North Fourth Street but burned down in the 1940s.

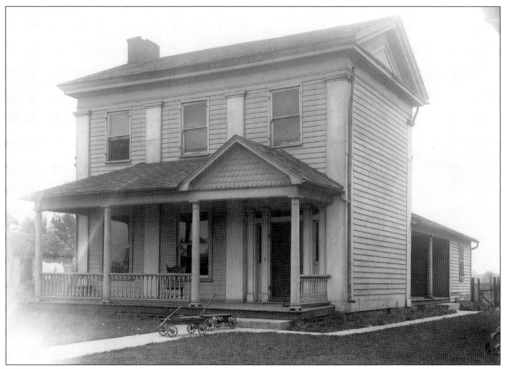

The Klinefelter home on East Main Street is pictured here before the flood of 1913. The house was moved to West Dow after the flood but was later torn down.

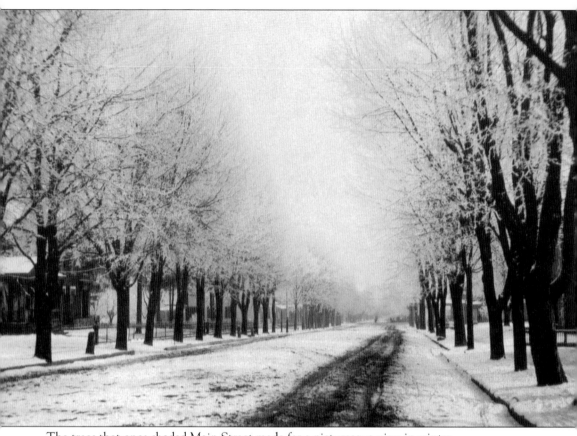

The trees that once shaded Main Street made for a picturesque view in winter.

Five

THE SCHOOLS

In the 18th century, the newly formed United States was based on an unprecedented belief that all people should have a voice in their government and the opportunity to rise above their birthright, and education became the cornerstone for that opportunity. Still, it was not until the Northwest Ordinance in 1787 that each township in the territory was required to set aside land for schools. The people of Tippecanoe have always prioritized public education. The following photographs showcase many of the town's former school buildings, teachers, and students.

This building held the first school in Hyattsville. In 1839, the closest school for Tippecanoe students was on Greenville-Springfield Road, and when enrollment increased to 107, the town saw the need for a bigger school building. It purchased .25 acres east of the canal for $15 and built a 20-foot-by-24-foot frame school for $13.30. This became district No. 9 for Tippecanoe.

John McPherson taught in the district No. 9 schoolhouse that was much like this replica. He was paid $75 to teach 56 children for 15 weeks. Every household was taxed, but when the coffers were low, McPherson's salary was reduced to $60. The following year, McPherson moved to district No. 2 in Hyattsville, and Samuel Mering was paid $50, with an assistant to "wield the rod" over 82 students.

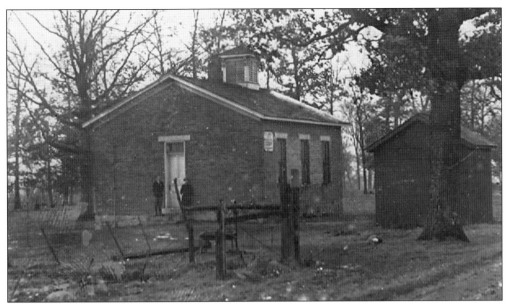

The township schools with names like Evanston, Gingham, and Cowlesville were used for nearly 100 years. The water pump and the outhouse seen here were at the former Picayune School on Hyatt just south of Evanston Road. Standing in the doorway are Lamoine Hecker and Tom Kyle, best friends until Lamoine died of diphtheria at age nine. Most of the schools have been converted to private homes or torn down.

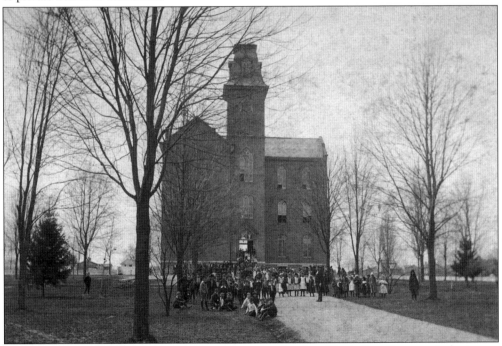

Tippecanoe continued to grow. In 1848, there was a school on North First Street and another on Dow and Third Streets. Later, Ben Herr ran a school in the Chaffee Building, and in 1868, Nana Booher taught in a shed. The following year, the school, shown here and considered to be "the finest in the country," was built on the hill, and in 1878, the first class of four members graduated.

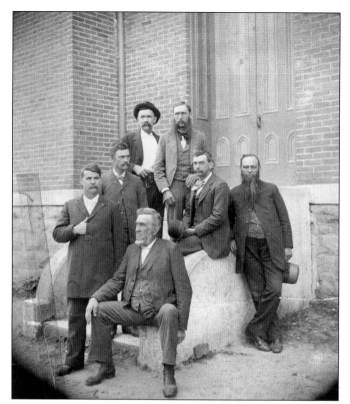

This is the school board that supervised the building of "the school on the hill" in 1868. These were important landowners for whom several roads around Tippecanoe were named. Seated in front is Jacob Rohrer. On the far right is J.W. Bowman, and in the back right is E.H. Kerr. Interestingly, also included in the photograph in the back row on the left is the janitor, William Collins.

James Bartmess began his career as a teacher in the Tippecanoe schools, and later he became the superintendent. He instituted a controversial new concept with the first graded school system in the area that abandoned the one-room schoolhouse and placed students in grades by age and ability.

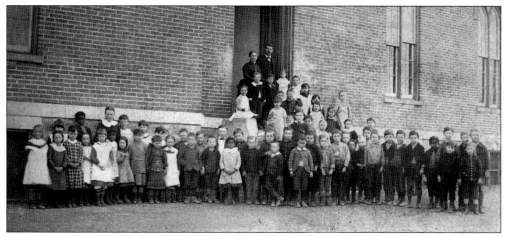

Posing in front of "the school on the hill" in 1882 are the elementary students. On the steps in the background are teachers Nellie Taylor and James Bartmess.

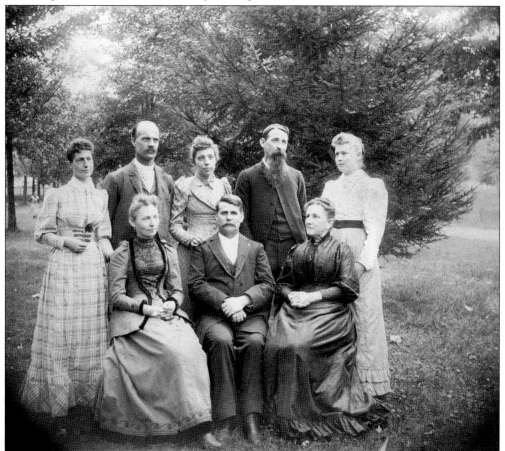

This was the entire staff of Tippecanoe High School in 1892. At that time, the male teacher with the most longevity was automatically the principal. The woman in the center of the back row is Bella Brump, known for her wooden hand. She wore a glove over it and carried a hanky in its curved fingers. She also used it on disruptive students by thumping them on the head.

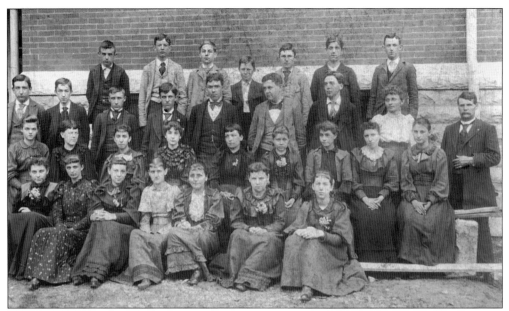

In 1894, this was the entire high school student body. James Bartmess can be seen standing in the third row on the right. The school board was planning yet another school building in anticipation of an increasing number of students.

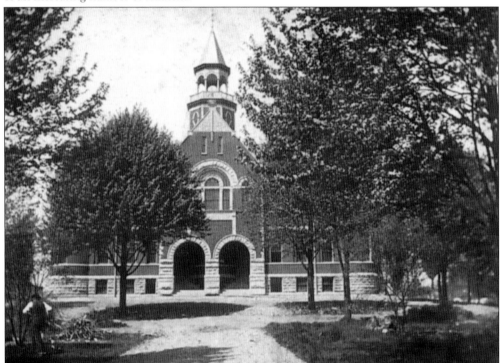

Built in 1894, "the Castle" was named for the turrets on the corners. It housed the entire school, first grade through 12th grade. The double arches in the front were entrances, one for boys and one for girls. A large, two-story hallway occupied the center of the building with wooden staircases leading to the second floor on both sides.

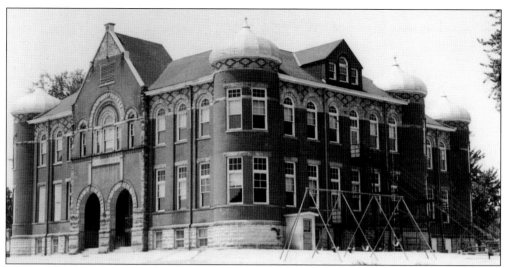

Here is another view of the Castle. For many years, the children were assigned to classrooms alphabetically, A–K and L–Z. The playground was divided into boys' and girls' sides with a wide line painted between them. The bell tower was eventually removed, and the bell is presently housed behind the former high school, now the junior high, in a brick structure.

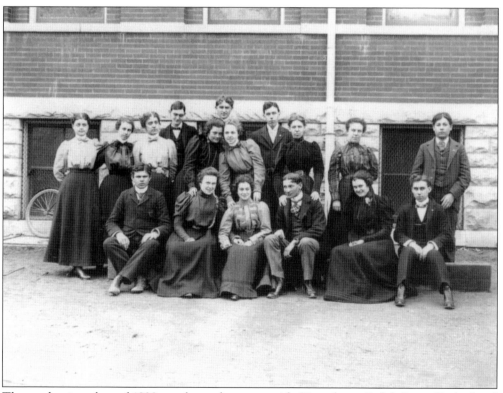

The graduating class of 1899 was large that year, with 17 students. Ralph Burwell, the local photographer mentioned in the chapter about Main Street, is in the back row on the far left. Notice the high-necked collars and the buttonhook shoes.

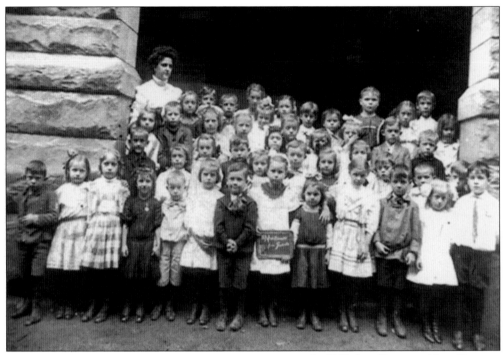

In 1901, Loa Davis and her 46 students were a typical size for a first-grade classroom. However, when graduation came around, only 13 students were left to receive diplomas. There were no laws requiring children to attend school, and most of the dropouts went to work to help support the family.

This was the typical size of a graduating class. Graduating was such an accomplishment that nearly everyone in town attended the ceremonies at the Chaffee Opera House. More often than not, all 800 seats were filled.

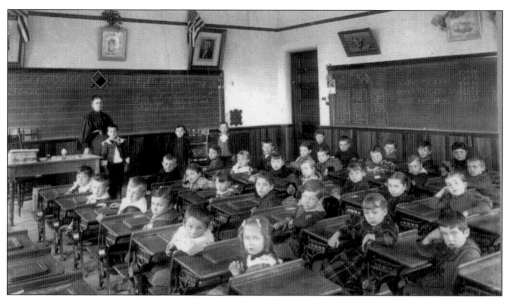

Just as today, class pictures were taken every year. In this elementary classroom in the Castle, the desks were bolted to the floor, and each child had a slate to work on. The lessons are on the blackboard, and the flag has only 43 stars.

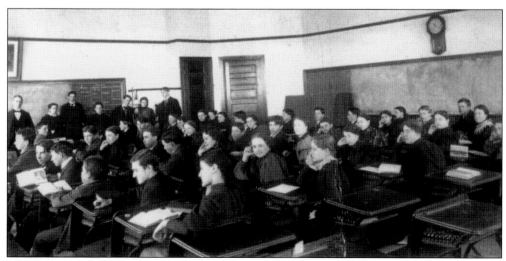

This is the entire high school in the Castle in 1897. In the right corner of the front chalkboard are the lessons for the day listed by grade level, and on the left chalkboard are conjugations.

By 1917, the "new" high school was built at Fifth and Dow Streets. It was state-of-the-art with three floors of classrooms, a library, science labs, and a gym, but the gym was so small the circles on the court touched. Fans had to move when a ball was taken out of bounds, and if a boy charged the basket, he could end up in someone's lap.

There was no football field, so every Friday afternoon the team ran down to a field east of the canal for the game, grabbing free apples as they ran past a store. But before the game, the field had to first be cleared of the cows and cow paddies. The downtown stores closed, and there were no stands, so the crowd "walked the line" up and down the field.

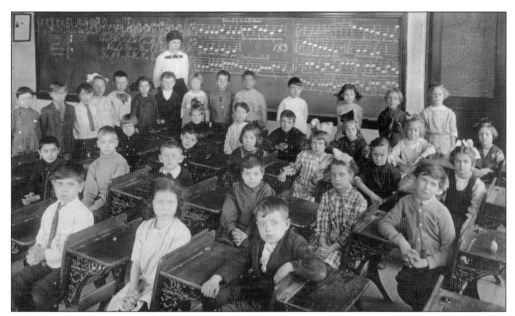

In 1929, there were widespread complaints about the poor quality of the high school band despite classroom music classes such as this one. People were embarrassed whenever the band played in public. The school board determined it was because there were only sufficient funds for one rehearsal a week, so in support, the board voted to fund two practices a week.

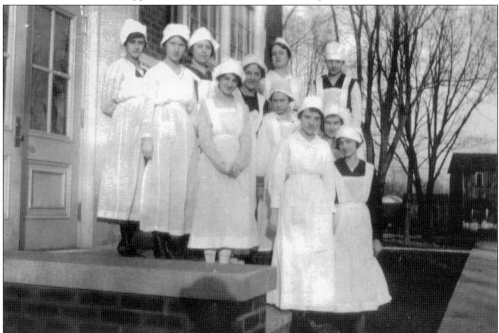

Shown here are domestic science students in their uniforms, but Supt. C.C. Smith argued that the school board was reactionary, by opposing domestic science classes and athletics. The 1929 board disagreed adamantly, and the debate became public. When some boys broke into the school, Smith asked board member M.T. Staley to reprimand them. Staley refused. Smith, fed up with the lack of support, resigned.

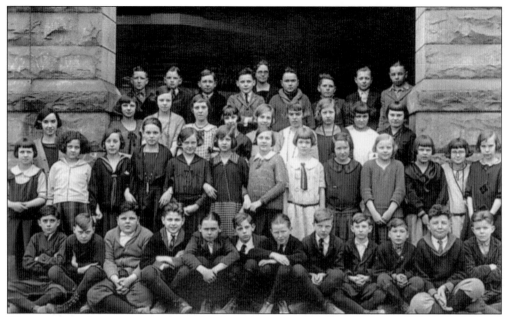

These sixth-graders were seniors in 1929 when money was discovered missing in a growing school scandal. At this time, the superintendent was also the treasurer, and $1,029.44 was unaccounted for. "Casual" accounting procedures by former superintendent C.C. Smith were blamed, and new superintendent Frank Nichols implemented stricter bookkeeping policies.

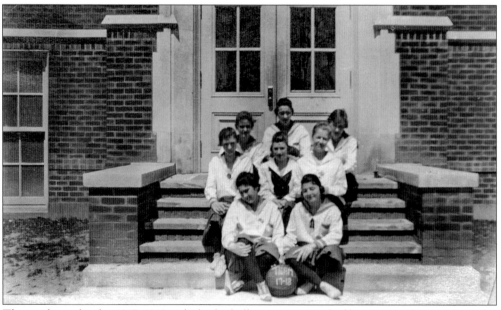

The uniforms for the 1917–1918 girls' basketball team consisted of leggings, a skirt, and a sailor top. Also at this time, girls were thought to be too weak or too ladylike to play on a full court, so half the squad was required to stop at the mid line, pass the ball, and wait until the ball came back to their side.

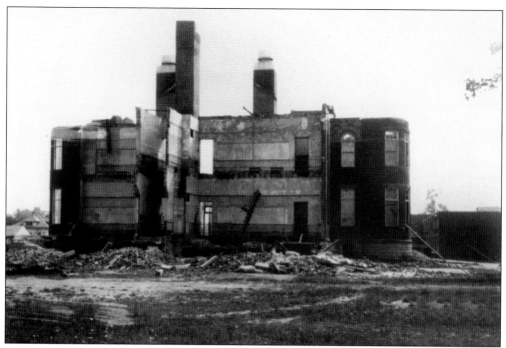

A bond issue was passed in 1966 to build a new elementary building, Broadway Elementary, and the Castle was torn down. The turrets came down first.

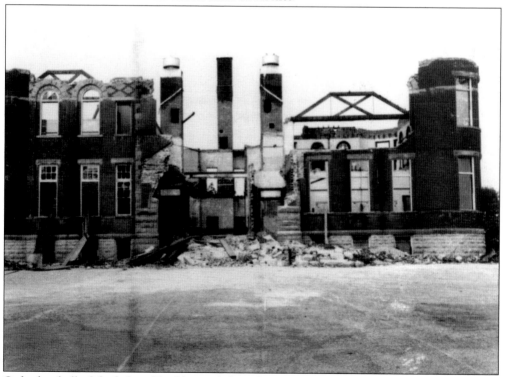

Only the shell of the beloved building is left in this photograph. Some of the Castle bricks can still be found in the dirt on the playground of Broadway Elementary.

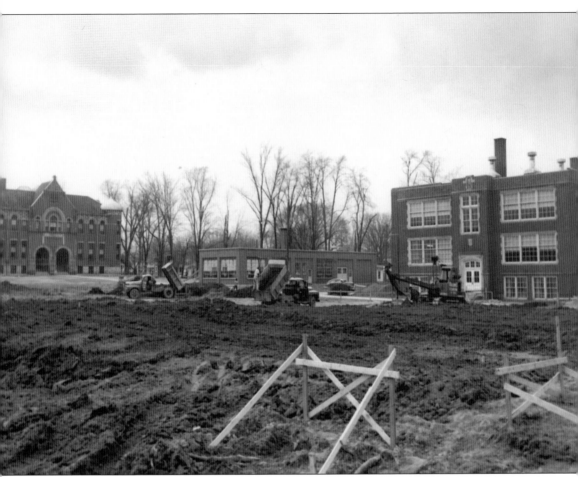

Both the Castle and the 1917 high school can be seen in this view of the building site on the corner of Broadway and Fifth Streets. A gymnasium was added to the south side of the 1917 high school that connected to the Broadway Elementary building, which extended along Broadway Street and back toward the Castle. The site of the Castle eventually became a playground. The Castle continues to be sorely missed by its students, and while it was indeed an impressive structure, it could not be brought up to modern fire or handicapped codes. It also was not suitable for the classroom flexibility needed for modern educational methods. Since the construction of Broadway, a second elementary, a junior high, and two high schools have been built to accommodate the educational needs of Tipp City's growing population.

Six

GETTING AROUND TIPPECANOE

When Tippecanoe began, the canal was the fastest and most efficient way to get products and people from one place to another, but this advantage did not last very long. Within a few years, the railroad came to town with its faster speeds and more convenient locations. Shortly after that, the electric traction car of the Dayton and Troy Line, called the D&T, stepped up to replace the railroad, followed by the Cincinnati and Lake Erie Bus Line, known as the C&LE. Then came the automobile, highways, semi-trucks, and the airplane. Tippecanoe took advantage of its location, and made use of each new development to grow and prosper.

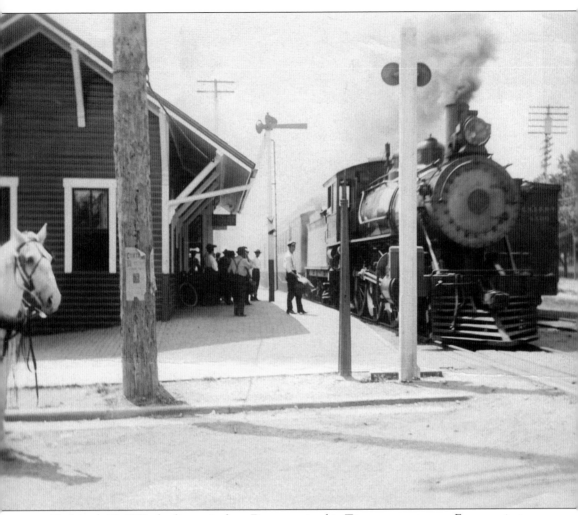

On March 28, 1853, the first train from Dayton arrived in Tippecanoe at noon. Everyone in town was invited for this historic first. The crowd watched as five cars filled with dignitaries arrived at the depot promptly on time. A cannon was fired, startling the more than 1,000 spectators. A reporter wrote, "One witness said as the train hissed and puffed up the track, 'They'll never get the gol' darn thing stopped.' And when it stopped right at the edge of the platform, the man said, 'I low'd as how they'll never get it started again.' He was wrong on both counts." Years later, on July 13, 1916, a freight engineer appeared before Tippecanoe mayor J.S. Scheip to answer the charge of speeding his train through town at 45 miles per hour, a clear violation of the four-miles-per-hour limit. He was fined $25 plus court costs of $2.10. Unable to pay and facing jail time, he asked to be released, promising to return in two days and pay his fine. His request was granted. And he did return.

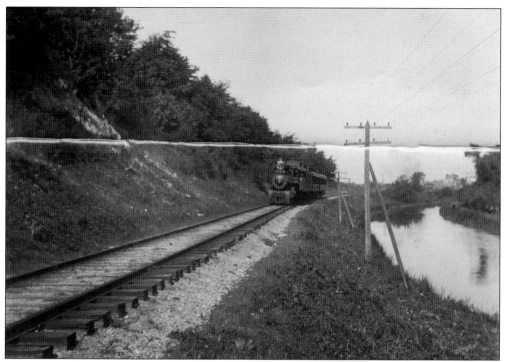

The train is rounding the bluffs north of Tippecanoe, beside the canal.

From 1853 through the 1920s, Orphan Trains came with orphaned children from New York City. The Children's Aid Society rescued orphans from wretched conditions and transported them to families in the countryside. In Tippecanoe, Frank Martin, shown here in his 1914 graduation photograph, was adopted by the Hill family. Frank "Speed" Hill proudly wrote "Speed Hill" on the Chaffee Opera House wall in 1915.

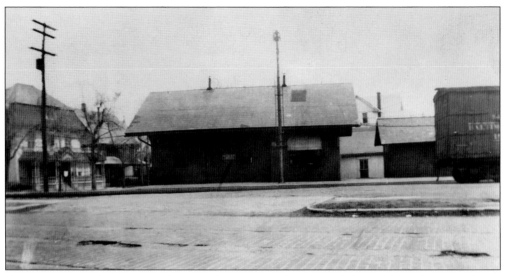

Two passenger and five mail trains stopped in Tippecanoe daily until 1954 when service was discontinued, and the train depot was torn down. Many remember when soldiers on passing trains handed letters to children to be mailed in town to avoid censorship. Hobos, who "rode the rails," often stopped at a notorious hobo camp north of Crane Road when that area was more wooded and secluded.

This is the Tippecanoe Freight Office. After trains gave up stopping in Tippecanoe, the railroad used the building for storage, and then rented it to the Tipp City Players for costume storage in the 1970s. Most recently, those costumes were moved to the third floor of the original 1917 high school on Dow Street.

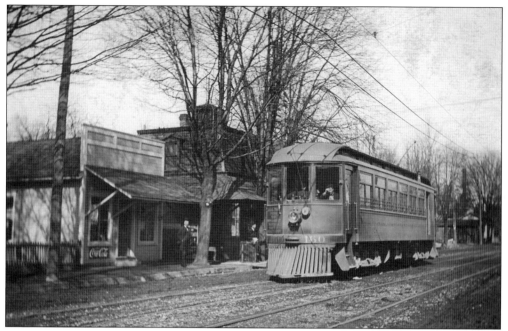

Starting in 1893, electric trains ran from Dayton into Piqua. When the route was extended to Tippecanoe in October 1901, the first Dayton-Troy car, known as the D&T, was greeted with the same excitement as the first railroad train. A hometown man, Peter Sprecher, was at the controls. People could ride all day for free between Tippecanoe and Market Street in Troy, and it only took 12 minutes.

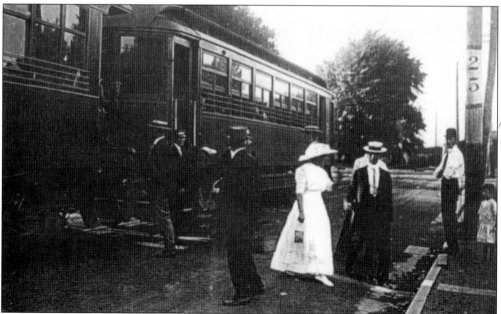

Conductors ruled their interurban trains with iron fists. Once, a passenger said he was not going to pay the 10¢ fare, so the conductor, William Love, pummeled him until blood spurted out of his nose. The man could not get the 10¢ out of his pocket fast enough. Another time, conductor Pete Hand punched out a man who refused to stop smoking in the presence of ladies on the train.

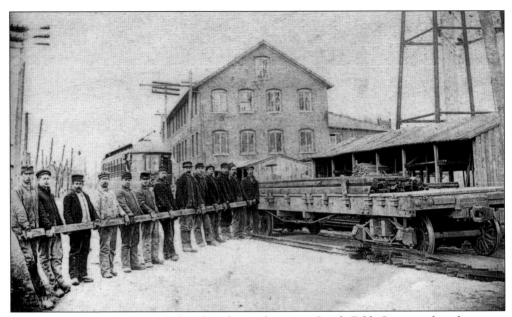

At one time, 175 men were employed at the car barns on South Fifth Street and at the power plant on Canal Street. The water tower in the background is no longer standing. Tickets for the traction and bus lines were sold out of John Shipley's shop on Fifth Street, later known as Jointer's, which can be seen in the photograph on page 95. It was torn down several years ago.

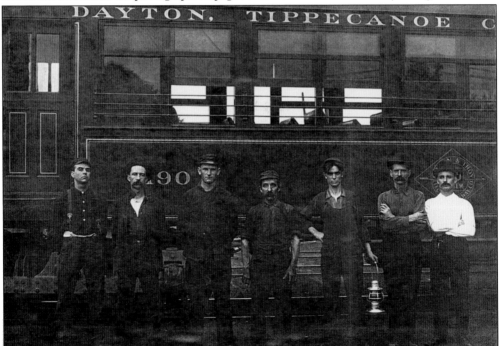

There is much controversy over the name given to the D&T cars, painted red and called "Red Devils." Some say it was because of the trains' high speed of 35 miles per hour. Others say it was the origin of the Tippecanoe High School mascot, the Red Devil. Still others say that the mascot was named after what is now a politically incorrect reference to Native Americans.

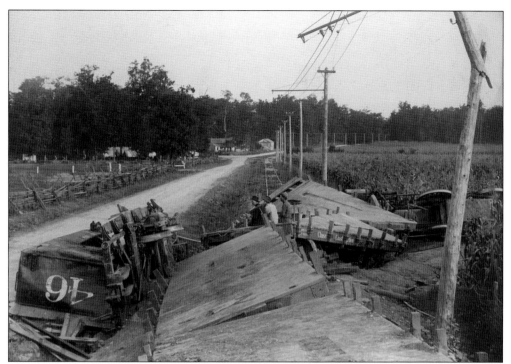

Interurban train crashes happened occasionally, usually due to siding miscalculations. This accident occurred north of Camp Chaffee on Tipp-Cowelsville Road. Notice the tracks on the right side of the road near the electric lines. The railway continually tried to upgrade its safety measures to avoid injuries to passengers.

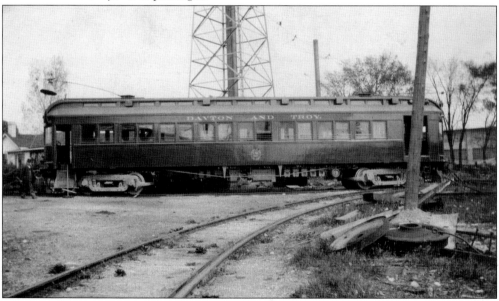

This is the last interurban car driven through Tippecanoe after the electric railway was replaced by C&LE bus service. Peter Sprecher, who drove the first electric traction car into Tippecanoe in 1901, also drove the last car on August 8, 1932. The time of the last run was very slow because Sprecher held down the whistle the entire way, which used additional power.

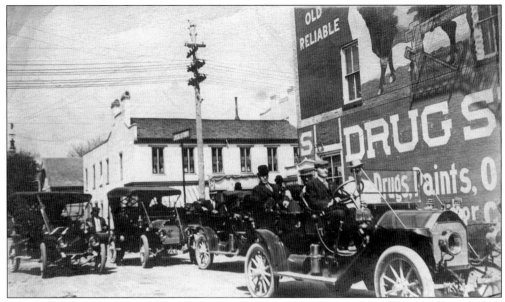

Automobiles soon took over the transportation needs in Tippecanoe. This photograph was taken on the corner of Second and Main Streets and shows Lewis Sheets driving in the front car. Early cars were standard, one color, and had no upgrades. They were ordered and delivered by rail within a few weeks. The advertisement on the side of the building is not the same one that was uncovered and restored several years ago.

Lewis Sheets, pictured here, was killed in this car in 1913. Ethel Hartman and Sheets were returning from Dayton when the car went off the road, slid on wet grass, and turned over. Ethel survived and later married, becoming Ethel DeLangton. She also worked in the public schools.

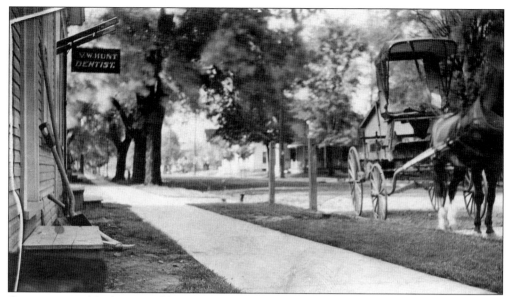

Getting around by horse and buggy was not totally abandoned after the introduction of the automobile. Both cars and horses were seen around Tippecanoe for many years. Dr. Hunt, a local dentist, still used his carriage.

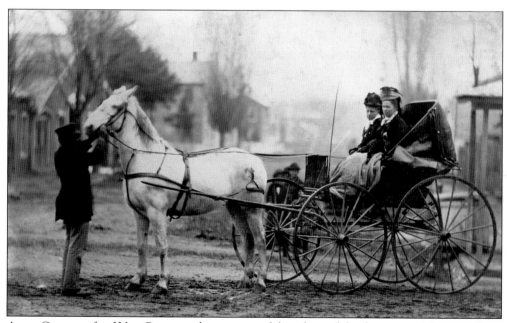

Anna Crane, wife of Van Crane, and an unnamed friend posed for this tintype photograph on Main Street in their horse and carriage.

In 1847, people petitioned the trustees of Monroe Township for a new permanent roadway. This petition lays out the intended route by naming the owners of the properties that the road would pass through. Tolls could be charged for any vehicle crossing their land. This new road was laid out from the canal west to County Road 25A on present-day Ginghamsburg Road.

Dirt roads were oiled to control the dust, and paths of sawdust were laid to avoid getting black oil over one's shoes when crossing the street. Having a paved road was a blessing that resolved the oil problem and created smoother and faster roadways. This new road ran east toward the Miami River on State Route 571. In the background, note the span of the old iron bridge.

Bicycles became very popular in Tippecanoe in the 1890s. This is the Tippecanoe Bicycle Club after a 12-mile Sunday ride to Ludlow Falls in 1897.

The late 1870s brought this two-wheeled bicycle to the United States. They were very unsteady and unsafe but quite a novelty when ridden by Ott King and Korah Hartley, both members of the Tippecanoe Bicycle Club.

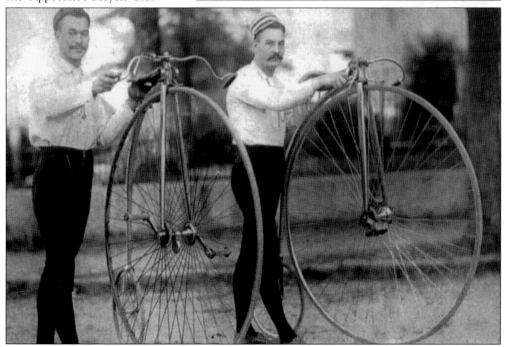

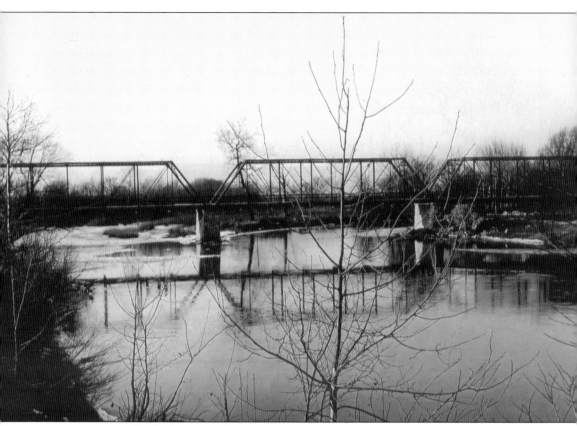

For many years, this bridge crossed the Miami River after the road took a sharp turn off what was then State Route 71, or Carlisle Road. In 1934, this bridge was abandoned, and the angle of the road was changed to cross the Miami River farther south. The contractor, John Hill, took his meals in Mary Neal's restaurant, and high school junior Loraine Suerdick worked there as a waitress. She was thrilled when Hill said, "I'm going to see you christen the bridge." He gave her $50 for a new outfit, and on October 11, 1934, she wore that outfit and christened the new bridge, naming it the John Clark Bridge after Tippecanoe's founder. Among the three-day festivities was a chance to win a car. A man from Piqua told Loraine if he won the car, he would give her $50, and he won. Loraine ended up receiving $100, a lot for a girl who made just $3 a week. When the bridge needed a new deck and superstructure improvements in 1985, Loraine, now Wollenhaupt, did the dedication honors again.

Seven

MORE PEOPLE, PLACES, AND STORIES

Sometimes people, places, and stories do not fit neatly into a category. Rather than lose the telling of them, this chapter is devoted to a collection of people, places, and stories that are unique to Tippecanoe. They are varied in their scope, but all give a further glimpse into the diverse life of Tippecanoe during its first 100 years.

This is the inside cover of Robert Evans's ledger written in his own hand. He wrote "March 2, 1821," "price 50¢," and this poem: "Steal not this book for fear of shame, / For above is wrote the owners name." It is filled with tidbits about the history of the people of early Tippecanoe. It included a notation that on August 4, 1837, James Hellum borrowed $5, and it was later crossed out indicating that Hellum paid it back. That same year, Evans "received of John Freeman 70¢ to buy flour." Another entry states that David Fair rented a stove for 50¢ a month and that he paid back 17¢ of the debt by filing a handsaw. In his will, Evans bequeathed shares of stock in the Miami County Branch of the State Bank of Ohio and his shares in the Miami and Montgomery Turnpike Company to his wife, Mary. He also left $5 to each of his grandchildren of his deceased children.

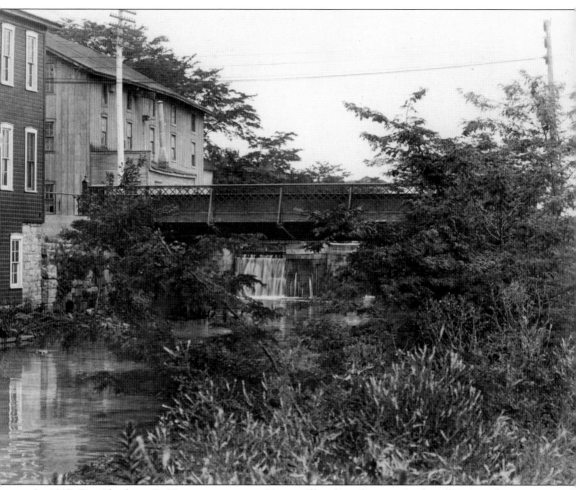

In 1837, Dr. Abraham B. Hartman came to Hyattsville where he practiced medicine and ran a tailor shop. He was active in city government and well respected. Then on December 4, 1875, he was found dead in the canal. Two months later, Samuel Cottral, James Hartman (the doctor's son), and Frank Kaufman were arrested for the crime. Illie Klinefelter and John Herr, also part of the gang, testified that Dr. Hartman had caught them stealing hams. At the Island Saloon, Dr. Hartman, who "was not above a few drinks himself," warned the thieves to stop "their nasty business." An argument followed, and Klinefelter swore that Kaufman had "done the deed," and tossed the body off the bridge into the canal. Five years later, the truth came out. Alex Lawrence, "the man who fed the hogs at the distillery," came forward on his deathbed. He had seen John Herr shake Dr. Hartman, break his neck, and dump the body into the canal. The three prisoners were released, but the real murderer was never captured.

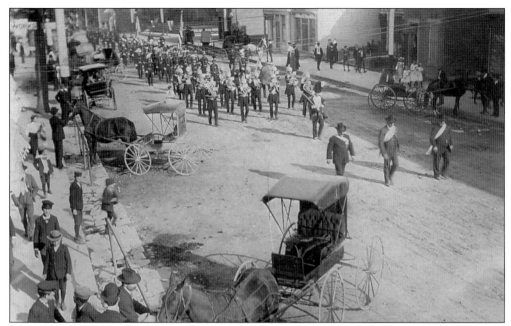

The exact date of this funeral procession is unknown. From the participants in the procession, the deceased would have been a member of both the Masons and the Independent Order of Odd Fellows. Minutes from the Masons for April 5, 1875, state that at the funeral of another member of both organizations, Brother Horton led the procession from the house to the church where Past Master Sam Cairns conducted the service. Then, the hearse was escorted to the cemetery. The lavish send off included the Tippecanoe Band. The men with the sashes walking ahead of the band are most likely from the Grand Army of the Republic, a Civil War veterans organization, but the $18 cost of the band was split between the Odd Fellows and the Masons. The family can be seen riding in the carriage in front of the hearse.

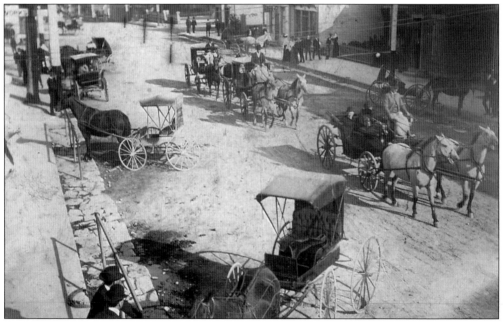

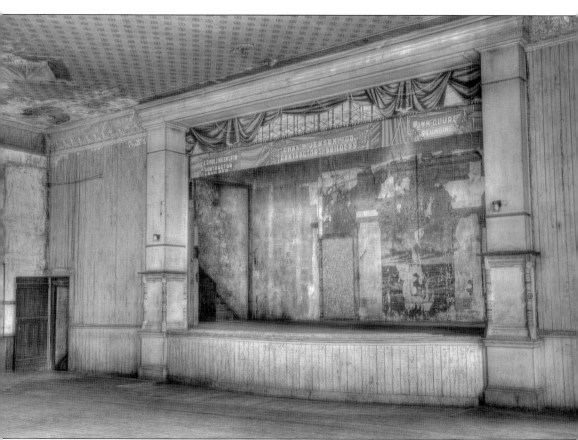

This formerly elegantly decorated Chaffee Opera House, now deserted, was opened in 1867. Sidney Chaffee, a wealthy distillery owner, built Tippecanoe's notable landmark by adding four rooms to an already existing structure on the corner of Main and Second Streets and then adding three more rooms behind that. Above it all, he built second and third stories. The extravagantly decorated second-floor theater had seating for 600 to 800 patrons, a more than generous capacity for a community of less than 1,000 people. Callie Dyche of Troy presented the first concert on opening night, which included arrangements made for a special train to leave Troy for the concert a few minutes before six o'clock and return a few minutes before 11 for 40¢. This acoustically perfect theater was the setting of numerous readings, concerts, and other presentations of interest over the years, including *Professor Richton's Wonder Show*, a vaudeville production that played for a week in December 1913. (Courtesy of Terry Glass, Tipp City.)

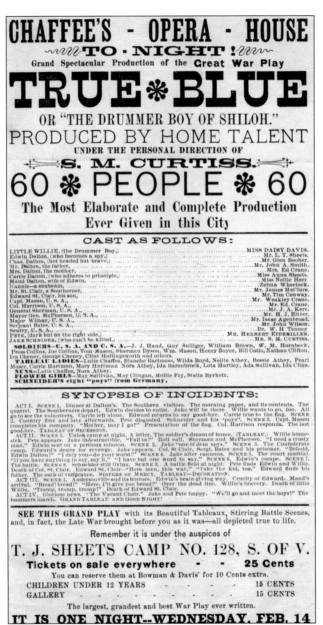

Col. J.H. Horton, a local playwright, penned several original plays about the Civil War and presented them at the Chaffee Opera House. *The Drummer Boy of Shiloh* was the first one with many familiar Tippecanoe names starring in the cast. On the afternoon before his production of *Sherman's March to the Sea*, he staged a reenactment of the battle in the streets. Capt. Daniel Rouzer portrayed General Lee, and the rebels were anyone who would wear his coat inside out. The Union soldiers consisted of 110 men from the Ohio National Guard, all Tippecanoe residents. The rebels were armed with old army muskets, while the Union side shot off one-pound cannon balls. The racket broke several nearby windows as the Union army poured down the streets from all sides and, of course, defeated the rebels. The stage version of the play, featuring live horses, was put on that evening with a second performance being added the next night to accommodate the overflow crowd.

In April 1881, the seats on the main floor of the Chaffee Opera House were removed, and it was converted into a roller-skating rink. One time, during the Grand March, the huge chandelier crashed to the floor, but luckily, no one was hurt. Elegant social balls were held there, with music, food, and refreshments. High school basketball games were played on the floor until 1917 when the new high school opened, and in 1922, a prizefight between Kid McCoy, also known as Paul Honeyman, and Tiny McGuinness, also known as Tiny Drewing, drew a crowd. Several churches used the space for services, and many people wrote their names on the walls of the upstairs rooms. Clarence Snyder, Bunch Zinke, and Robert Jackson left their marks on September 13, 1908. A.W. Schultz painted his name in huge letters on the walls on May 1, 1923. Use of the Chaffee Opera House has been very limited since the 1940s. However, even now, empty and unused, it remains an impressive space. (Courtesy of Terry Glass, Tipp City.)

The fire at Tipp Cabinet, formerly Tipp Building and Manufacturing, made the graduation of 10 students on May 21, 1903, at the Chaffee Opera House an eventful evening. Despite torrential rains, nearly every one of the 800 seats was filled to hear each graduate present. At 9:05 p.m. in the middle of Louis Mitchell's speech on the future of our country, the fire bell went off. Mitchell had to raise his voice to be heard over the uproar of people rushing to answer the call. Tipp Cabinet was ablaze after a flash of lightning ignited crossed electrical wires. Flames could be seen in Troy and Piqua, but deep mud and rain delayed the arrival of additional firefighters. Several nearby buildings caught fire, but others were saved by the rain. Crews fought for 12 straight hours before the blaze was brought under control, while the women supplied coffee and food. Back at the opera house, anyone who had not been called to duty remained until the graduates had received their well-deserved diplomas.

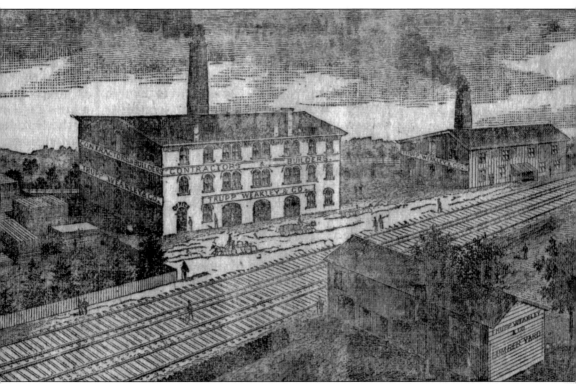

Tipp Building and Manufacturing, begun by Charles Trupp soon after the Civil War, built most of the houses in Tippecanoe for nearly 30 years. Then in 1894, R.H. Ritter converted it to making kitchen cabinets and tables. The now Tipp Cabinet did not have enough insurance to cover the fire damages of $35,000 to $45,000, so other local factories took on the task of manufacturing and filling any of its outstanding orders. They also offered available jobs or created new ones for the workers who had lost theirs. The *Tippecanoe Herald* reported, "The company has shown conclusively that they mean to let their employees suffer no loss of wages, if possible, and in this respect the disaster has brought employers and employees closer together than anything else could possibly have done." Tipp Cabinet had considered relocating, but after the town's support, it promised to stay and rebuild. This is just one of the many examples of how the people of Tippecanoe united together during adversity.

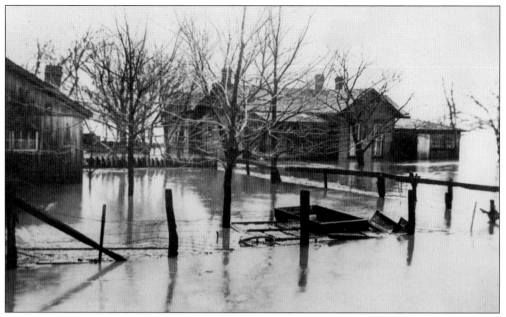

The weather conditions in March 1913 brought devastating floods to the Miami Valley. Heavy rains started on Sunday, March 23 and continued through Wednesday, March 26. The rivers and sewers could not handle the runoff, and by Monday, homes east of the canal were underwater. The men cut a breach in the levee with shovels and pickaxes to divert the water and built protective dikes around the power plant.

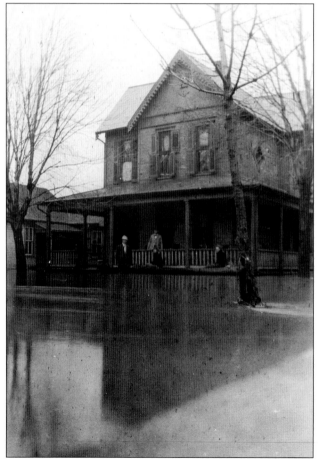

Torrents of water rushed down Bulls Run and Plum Streets, flooding houses like Wilhelm Koetitz's on Third and Plum Streets. Large portions of the railroad bed washed away. Phone and telegraph lines were dead, and Tippecanoe was without contact from the outside world for several days. By Tuesday, the fire bell rang nearly continuously, calling for more volunteers to assist people in the bottomlands in getting to safety.

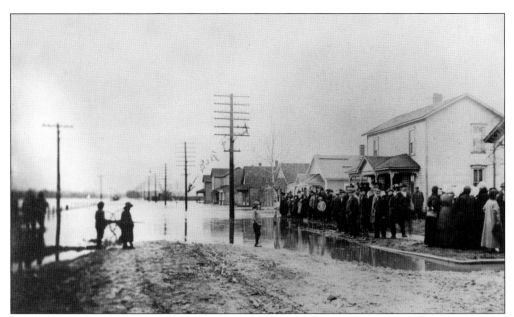

Tipp bakeries made thousands of loaves of bread. The traction line carried supplies to the traffic circle where boats took it into flooded Dayton. Of the 20 houses east of the canal, 14 were moved to higher ground. The houses were lifted onto large logs, and horses pulled them up the streets using wagon wheel–sized pulleys at each intersection. People lined the streets to watch.

Royal Baking Powder was first available in Tippecanoe. A man who could not pay his bill on the nearby stagecoach line gave the recipe to the innkeeper who fried raised doughnuts for his passengers. The soil here is not suitable for growing the grapes necessary for the tartar, and the company moved to New York State. In the 1940s, owner Jacob Dettmer willed enough money to build Dettmer Hospital in Troy.

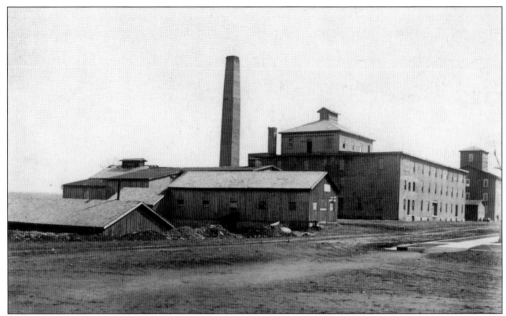

These industries on First Street include Timmer's Cooperage Shop that sat below street level (only the roof can be seen); behind that is the Tippecanoe Grape Sugar Company, which was closed after an explosion in 1887; in the background is Davis Whip. The site of the grape company later became Tip Top Canning, which sells its products nationwide and fills Tippecanoe with the smell of tomatoes every summer.

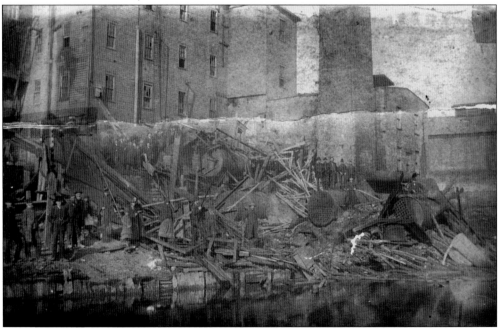

This is the aftermath of the Grape Sugar Company explosion. The factory processed grape sugar, also called dextrose or glucose, which in powdered form is used in many food products. However, fine particles can become explosive when exposed to air. Powdered glucose is also extremely flammable and must be kept away from open flames and areas where electric sparks are possible.

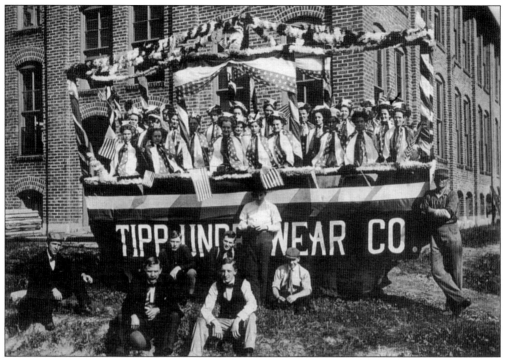

The Underwear Factory opened in 1907 on North Fourth Street for the manufacture of knitted underwear. During World War I, as the Tippecanoe Knitting Mill, it made wool shirts and drawers for the military. In 1930, the factory was absorbed by Piqua's Superior Underwear, and the building stood empty until 1936 when Dolly Toy purchased it.

Dolly Toy began as the Dolly Kite Company, but then started making toys out of leftover cardboard. It soon became nationally recognized as the leading manufacturer of seasonal novelties and nursery decorations, such as shown here. The company closed in 2008 because of dwindling markets and foreign competition.

Another of Tippecanoe's nationally known businesses is Spring Hill Nursery. It started in 1889 as Bohlender's Nursery. When Peter Bohlender retired in 1900, he left management to his son Fletcher and son-in-law Harry Kyle, who changed the name to Spring Hill. In 1930, as a mail-order nursery, it became known for its quality plants and flowers. Growing acres of chrysanthemums led to sponsorship of the popular annual Mum Festival.

James Scheip began Tipp Novelty in 1897, making smaller novelty whips from old buggy whips. Four generations of this family-owned, mail-order business have at various times painted materials for the government during World War II, sold numerous novelties items, and specialized in printing logos on ceramic pieces such as mugs and glasses. It closed in 2011, but some of its products can be purchased on websites, such as eBay.

In 1879, the Crane family owned a large dog as a playmate for their son. The family moved to Michigan where the boy died. After burying his son at Maple Hill Cemetery in Tippecanoe, Crane placed a life-size iron dog on the grave as a tribute. The Iron Dog could be seen by passing trains and appeared to passengers to be a real dog. Simon Lindsley, a frequent traveler, embellished the tragic tale of the beloved pet that would not leave his master's side. Some passengers sent money to build a shelter, and others scolded the railroad for letting the dog suffer outdoors. Eventually, the *Associated Press* picked up the story, and newspapers all over the country printed the mournful tale. More than 20 years later, the exasperated railroad asked the Cranes to move the dog, and today it stands on the corner of 25-A and Evanston Streets. The child next to the Iron Dog is modern-day Brandon Hadden. (Courtesy of Fred Stivers.)

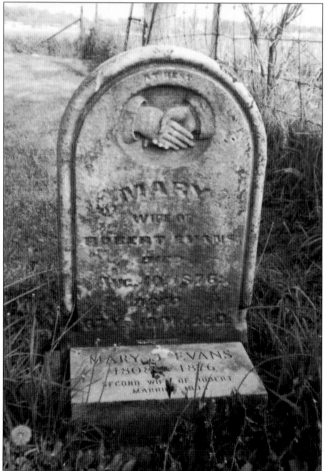

Robert Evans and his first wife, Esther, are buried in Pearson Cemetery, located behind the Monroe Grange on Peters Road, about three miles west of town. Esther died shortly after the birth of their 10th child. For Robert, clearing the land proved more difficult than he had predicted, so he traded his 140 acres for John Clark's more fertile and partially cleared land to the west.

Soon after Esther's death, Robert married her cousin, 27-year-old Mary Jenkins, and had six more children. Mary survived Robert by 13 years, and his will stated that she would keep her inheritance only if she "remained his widow." This included the land, his financial assets, and "her choice of two cows and one horse." Her grave is about 10 feet to the left of his.

Eight

TIPPECANOE TO TIPP CITY

Mail delivery right to home mailboxes is something that many take for granted, but in the first 100 years of Tippecanoe, mail delivery was a continual source of irritation and confusion. Neither snow nor sleet nor dark of night could stop the postal carriers, but where the letters and packages would actually be delivered constantly changed throughout Tippecanoe's history. It was the mail-delivery chaos that led to the name change from Tippecanoe to Tipp City in 1938.

The federal government did not issue stamps until the 1840s, and before that, the local postmaster could determine postal rates and run the post office wherever he wanted to, usually in his place of business. The 2¢ stamp shown here was issued before World War I. Starting in 1832, mail was carried to Hyattsville once a week to Henry Hyatt's dry goods and tailor shop on horseback by a 10-year-old boy named Kiel Hoagland. By 1835, the post office had moved to the tavern of Samuel Shyrock on the southwest corner of present-day Hyatt and Main Streets. Two years later, Joseph Max became postmaster on the opposite corner. Then, around 1850, the Hyattsville postmaster, Dr. J.K. Gilbert, moved into Tippecanoe, but the government would not allow the post office name to change because the towns were so close together. Tippecanoe had a post office, but all the letters still had to be addressed to Hyattsville.

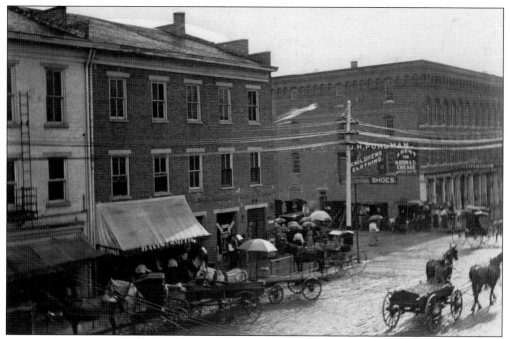

Shown here are two of the many post office locations in Tippecanoe, the Morrison Building on the left and the Chaffee Building on the right. Others included the rear of the City Hotel, a building on the corner of Sixth and Main Streets, and a confectionery store on North Second Street. Banks moved with equal frequency, and while in the Chaffee Building, the bank and the post office shared the same vault.

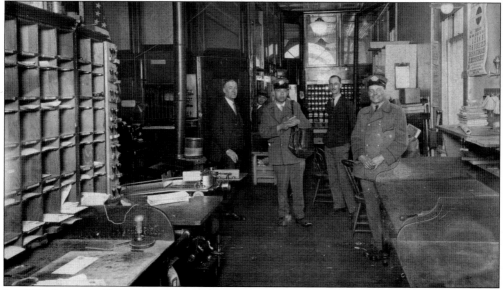

In 1925, the post office was upstairs in the Tippecanoe City Building. Free mail delivery to the homes began in 1923, with the city carriers walking about 18 miles per day and the four rural horse and buggy routes averaging the same. Later, two motorcars replaced the buggy routes. Left to right are Clyde Bennett, postmaster; Arthur Judd, city carrier; Robert G. Davis, assistant postmaster; and Guy T. Parsons, city carrier.

This building on Third and Walnut Streets was owned by Mr. and Mrs. W.E. Ratcliff and was leased as the post office from 1929 to 1939. On opening day, Mrs. N.O. Johnson mailed the first letter, and Erie Pearson bought the first stamp. This office was also the first to accept mail under the new name of Tipp City in 1938. It is now the Tippecanoe Historical Museum.

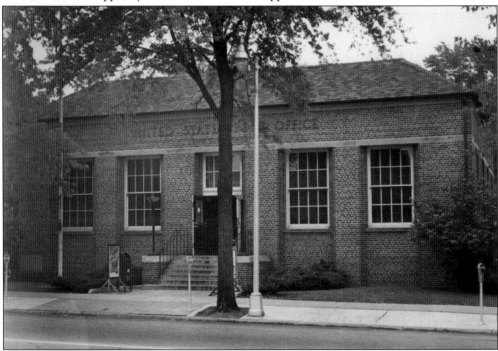

From 1939 to 1991, the corner of Fourth and Main Street served Tipp City as the post office. There was one stipulation: the grave in the northwest corner of the lot of a horse belonging to Daniel Rouzer was to be left undisturbed. When Rouzer died in 1881, his will stated, "No stable, barn, woodshed or other cut building shall ever cover the grave." A statue now commemorates the site.

Col. Daniel Rouzer was an officer with Company E of the 44th Ohio Infantry, known as Rouzer's Raiders during the Civil War. His prized horse carried him safely through many battles and brought him home at the end of the war. Daniel and his wife, Mary, kept the horse in the backyard of their home on the corner of Fourth and Main Streets, shown here. When the horse died, Daniel buried it, along with the saddle, and allegedly included a conditional clause in the deed to preserve the grave. After an extensive search by the government for a new post office site, Rouzer's great-great-granddaughter sold the lot for $5,000 but only if that clause was honored. The Rouzer house, one of the oldest in Tippecanoe, was moved to Miles Avenue, and the new post office was built in 1939. Tippecanoe historian, Grace Kinney, says this legend is not true, but the statue and the burial site of the beloved horse continue to be respected.

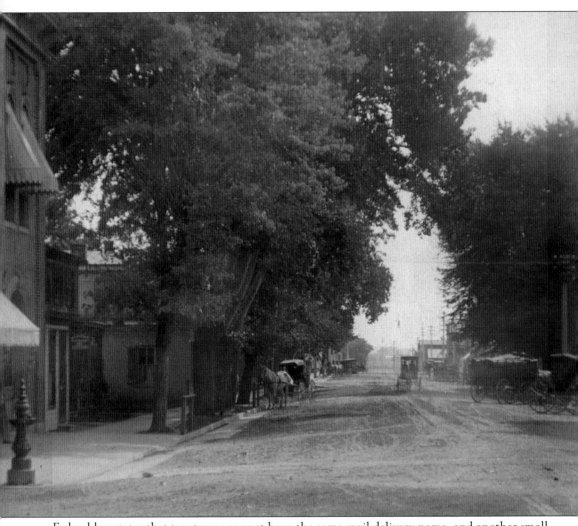

Federal law states that two towns cannot have the same mail delivery name, and another small town about 185 miles to the east in Harrison County, Ohio, is also Tippecanoe. The view down Main Street looked much like this in 1877 when the following appeared in the *Tippecanoe Herald* from the postmaster of Harrison County: "The Post Office Muddle. Tippecanoe, Harrison County is a small town twelve miles south of this place. . . . They receive all their mail . . . twice a week on Mondays and Fridays. Fully one half of the mail matter addressed to that office is intended for your office. . . . A large amount of written matter comes from Dayton, Ohio and therefore causes long delays. . . . Can there not be something done to correct these errors?" To alleviate the confusion, the word "city" was added for postal delivery only. Tippecanoe City became common usage, but the mail problems continued for another 60 years.

o-o-our n-n-new n-n-name

Tipp City, Ohio

[Miami County]

c-c-changed f-f-from

Tippecanoe City, Ohio

Then, one day, city leaders had enough. On August 9, 1938, the following petition was filed by the Court of Common Pleas. "This day, this cause comes on to be heard on the petition of James R. Scheip and others, free holders of the Village of Tippecanoe, Miami County, Ohio, praying for the changing of the name of said Village to the Village of Tipp City, and upon the evidence was submitted to the Court . . . that said petition was signed by at least twelve free holders of said Corporation; . . . that the prayer of said petition is just and reasonable; that at least three-fourths of the inhabitants of said Corporation desire such change, and there is no other municipal corporation . . . having the name prayed for." Today, there is lingering doubt that three-fourths of the inhabitants desired the change, or even knew about the petition, but nevertheless Tippecanoe became Tipp City.

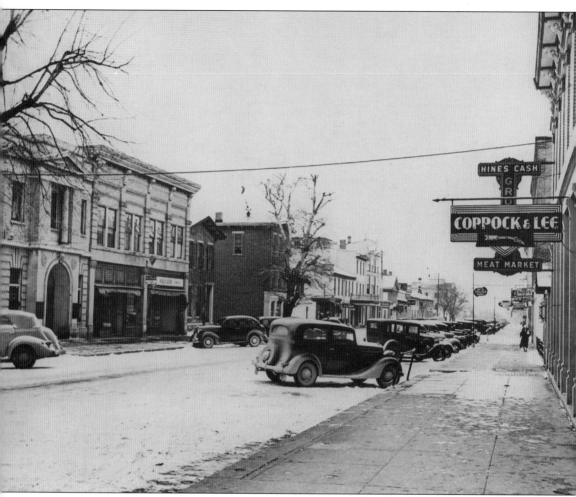

This is how Main Street Tippecanoe looked around the time of the name change to Tipp City, and the controversy continues today over whether to keep that name or return to the original name of Tippecanoe. Those in favor of returning to the old name say that in this age of zip codes there would be no mail mix-ups and that the vast difference in populations of the two towns would also make any problems unlikely. The population of Tipp City and Monroe Township is close to 17,000, versus that of the Tippecanoe of Harrison County, which is only 121. The argument against the change back to Tippecanoe is that letterheads, road signs, and documents, among other things, would have to be changed, and the expense would be overwhelming. This disagreement will continue, but for now, Tippecanoe is Tipp City.

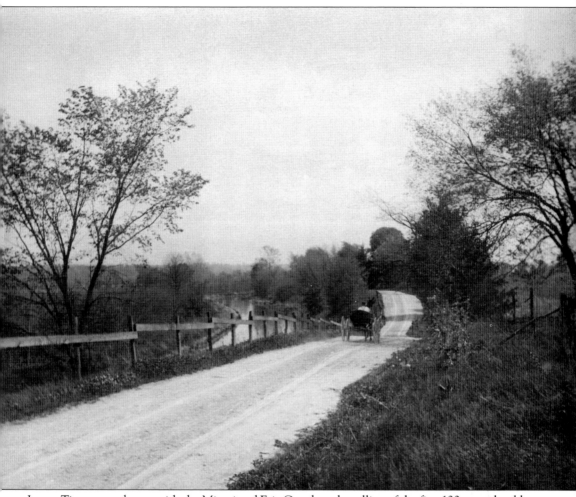

Just as Tippecanoe began with the Miami and Erie Canal, so the telling of the first 100 years should end with the canal. This may seem like a rather lonely photograph, but the legacy left behind by Robert Evans, John Clark, and so many others is anything but lonely. Those at the founding of Tippecanoe left a legacy that continues to grow with the people of Tipp City today. As the settlers conquered the forest wilderness to build Tippecanoe, so do the modern-day residents strive to take control of the vastly different wildernesses of today's world in Tipp City. The first 100 years of Tippecanoe were exciting and prosperous, and the future of Tipp City for the next 100 years and more looks equally as bright. This book has told only a few of the many stories of the people who were so busy living their lives that they didn't know they were living history.

Discover Thousands of Local History Books
Featuring Millions of Vintage Images

Arcadia Publishing, the leading local history publisher in the United States, is committed to making history accessible and meaningful through publishing books that celebrate and preserve the heritage of America's people and places.

Find more books like this at
www.arcadiapublishing.com

Search for your hometown history, your old
stomping grounds, and even your favorite sports team.

Consistent with our mission to preserve history on a local level, this book was printed in South Carolina on American-made paper and manufactured entirely in the United States. Products carrying the accredited Forest Stewardship Council (FSC) label are printed on 100 percent FSC-certified paper.

MADE IN THE USA